WATER
PAPER
PAINT

Exploring Creativity with Watercolor and Mixed Media

BEVERLY MASSACHUSETTS

QUARRY BOOKS

HEATHER SMITH JONES

First published in the United States of America by

Quarry Books, a member of
Quayside Publishing Group
100 Cummings Center
Suite 406-L
Beverly, Massachusetts 01915-6101
Telephone: (978) 282-9590
Fax: (978) 283-2742
www.quarrybooks.com
Visit www.Craftside.Typepad.com for a behind-the-
scenes peek at our crafty world!

Library of Congress Cataloging-in-Publication Data
Smith Jones, Heather.
 Water, paper, paint : exploring creativity with watercolor
and mixed media / Heather Smith Jones.
 p. cm.
 Includes bibliographical references.
 ISBN-13: 978-1-59253-655-9
 ISBN-10: 1-59253-655-7
 1. Watercolor painting--Technique. 2. Mixed media paint-
ing--Technique. I. Title. II. Title: Exploring creativity with
watercolor and mixed media.
 ND2422.J66 2011
 751.42'2--dc22

 2010031920
 CIP

ISBN-13: 978-1-59253-655-9
ISBN-10: 1-59253-655-7

10 9 8 7

Cover artwork: Heather Smith Jones
Design: Nancy Ide Bradham, bradhamdesign.com
Photography: Rachel Saldaña, buttonsmagee.com

Printed in China

WATER
PAPER
PAINT

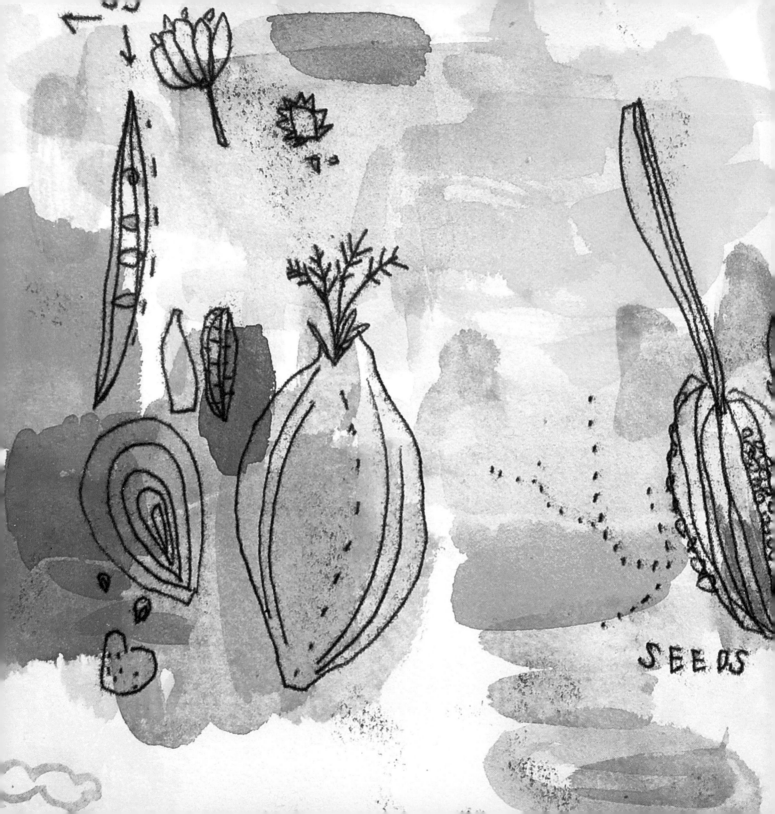

SEEDS

This book is dedicated in memory of my grandmothers and for their impact on my life and art. My maternal grandmother helped support me through graduate school, wrote letters of encouragement, and spread light to us grandchildren through her laughter. When I remember my paternal grandmother, I think about her warmth, appreciation for beauty, and love for color. She passed away during the writing of this book.

AGH THIS BLOWS MY MIND

2.

4.

CONTENTS

WATERCOLOR:

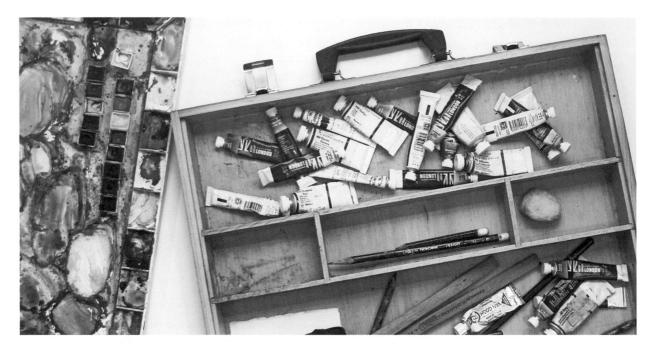

A Personal History

Watercolor may be the earliest paint one encounters as a young child. A simple paint set of colors and a soft-haired brush connect a young person with his or her thoughts and help directly communicate impressions of the nearby world. Perhaps you recall watching liquid pools of color blend together for the first time. Working with watercolor is immediate and spontaneous, yet it is also dramatic, able to stir wonder and mystery.

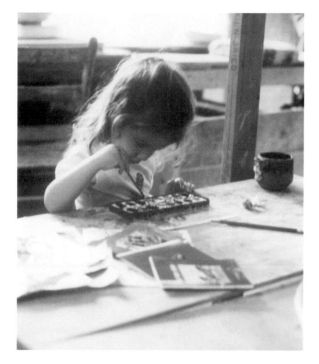

The author as a young girl

I began taking watercolor lessons as an adolescent and remember sitting on the beach with a watercolor paper block and plastic palette full of tube watercolors. My instructor showed me how to hold the flat brush and glide it back and forth to paint the waves as they moved to shore. He made it look effortless and captivating. The blue-green ocean seemed to wash itself onto his paper. When I painted the same water, I remember being frustrated trying to paint like someone else and was probably straining beyond my skills.

My interest in watercolor was renewed in graduate school when our professor demonstrated how to make watercolor paint by hand, grinding the pigments one by one with water and gum arabic. There is so much room for discovery in mixing paints from raw ingredients. Through the nuances of paint-making processes and by incorporating different materials and ways of applying them, I try to reshape the medium for my work. By experimenting, I have learned that I like to include layers of transparent color with areas of opaque handmade watercolor in my paintings. I tend to mix white with a color to make a tint, as well as allowing the white of the paper to show through in other areas. These technical aspects can impart and support the concepts within the work.

Through the projects in this book and in practice, try to unearth your own strategies. Blend tradition with new methods. Combine what you know with a zeal for discovery and find new ways to approach the painting process. Make the paint work for you and convey your ideas so you can create your own work, unlike that of anyone else.

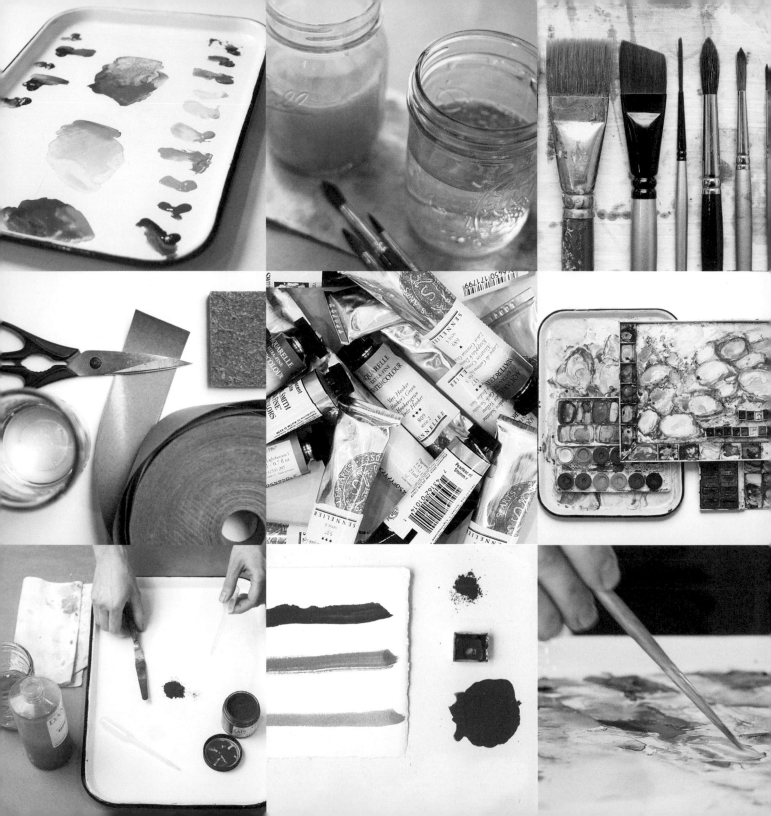

CHAPTER ONE:
BASICS

Not everyone has had the opportunity to experiment with watercolor as a child or even as an adult. If you want to try painting with watercolor for the first time and wonder how to begin, take a few moments and read the basics chapter which discusses paper, paint, palettes, and brushes. Become familiar with the materials and how to set up for a painting session.

The paper section discusses the different types, how it is made, and how to prepare paper before painting. The paint section covers the three types of watercolor used in *Water Paper Paint*, as well as how to make your own paint. The palettes section is comprehensive and begins with examples of palette supports and ends with a discussion about the color wheel and color systems. You will also learn about the characteristics of color, how manufacturers label paints, and a suggested selection of paint colors with which to begin painting. The brush section introduces the types of brushes, how to use them, and the numbering system manufacturers use for sizing. It includes a suggested list of brushes to use for the projects chapter of the book and some simple tips for brush care.

PAPER

The projects in *Water Paper Paint* use three main types of paper: rough, cold-press, and hot-press. These terms refer to the surface quality or smoothness of the paper. We'll review the substrate options, their characteristics, and how to use them on the following pages.

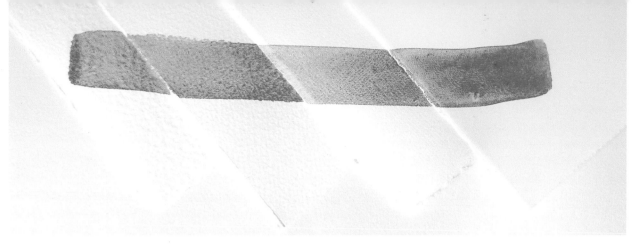

Watercolor paper types (left to right): rough, cold press, soft press, hot press

Paper Types

For centuries, fine paper makers have used a mold to form the sheets. A mold is a wooden frame with a fine screen stretched across it. It is dipped into a mixture of cotton fibers, sizing, and water and when lifted, it holds what will be the sheet of paper. As the fibers dry they bind together. The irregular border of the fibers form what is called a deckle edge. Today the screens used to make paper are much longer, so once cut to size, water-color papers may have a combination of deckled, cut, or torn edges.

Cotton fibers, or linters, are used in making watercolor paper instead of tree fibers. Tree fibers have been found to yellow over time as the paper becomes more acidic from exposure to ultraviolet light. Substances like calcium carbonate are added to the cotton pulp to make it more alkaline and increase the life of the paper.

Once the sheets are made, they are rolled through cylinders to press the paper fibers. Cold cylinders produce cold-press paper, a sheet with a texture between rough and hot. Cold-press paper (CP) is a popular choice among watercolor artists. Hot cylinders make hot-press paper (HP) a paper with a smooth and satiny finish. Hot-press paper is a good choice for work that involves detail either in drawing or paint. Rough press paper is not pressed, giving it a very toothy grain. Generally, rough paper is suited for wet-into-wet techniques since the surface is highly absorbent. Because it is also very durable, it is a suitable choice for mixed-media work. In addition, some paper makers, such as Fabriano, make a soft press paper, which has a velvety surface, offering a version between hot-press and cold-press.

During the paper-making process, manufacturers size the paper sheets with natural or synthetic gelatin. The sizing permeates the paper to allow for better paint adhesion and vibrancy of color. It also makes the paper more durable and less absorbent to excess water when painting.

Preparing Paper

Stretching watercolor paper before painting is sometimes necessary to prevent rippling. While some artists do not mind paper rippling, it is helpful to know what causes it. Two factors help determine if stretching is needed: the weight or thickness of the paper and the intended painting process. Watercolor paper is available in sheets, rolls, and blocks and is measured in pounds per ream (lb) or grams per square meter (gsm). Two common and easily found weights are 140 lb (300 gsm) and 300 lb (640 gsm). Paper of 300 lb or more is very thick and generally sturdy enough without stretching. For paper that weighs less than 300 lb, such as 140 lb or less, the second determining factor warrants consideration. If you intend to saturate the paper with paint, then you should stretch it first. The more water you apply to the paper, the more likely it is to buckle.

If the painting process entails drawing with additions of watercolor or thin glazing, you may be able to skip the stretching step.

MATERIALS

- watercolor tape
- piece of watercolor paper
- container for water
- sponge
- large flat brush, 1″–2″ (25–51 mm) wide
- craft knife
- straight-edge ruler
- wood or Masonite support

Process

1. Before stretching the paper with watercolor tape, make sure to cut or tear the paper larger than necessary. Allow for an additional 2″ (5.1 cm) on top of your desired margin in both length and width. To tear the paper, set it on a clean flat surface and hold a straight-edge ruler down on the line where you want to tear. Hold the ruler steady with one hand as you use the other hand to lift and tear the paper against the ruler edge. It will form a deckle edge as you tear.

2. Lay the watercolor paper on a work surface. Use a large flat brush dipped in clean water and wet the entire surface of the paper. Make sure the paper is thoroughly wet but without puddles. Turn the paper over and repeat on the other side. Alternatively, use a clean sponge rather than a brush to wet the paper or soak the sheet of paper in a large vat of water for a few minutes.

3. Place the wet paper on a wood drawing board or fiber board, such as Masonite. Use clean hands to smooth out any ripples, rubbing from the center to the edges of the paper. Tear four strips of watercolor tape, each slightly longer than the edges of the paper. Dip a clean sponge in fresh water and moisten the gummed side of one tape strip. When it is completely moist, lay the strip on an edge of the paper with one-third of the width of the strip set on the paper and two-thirds adhering to the board. Press it down firmly with your hands, rubbing from the center to the edges. Repeat the same steps with the remaining three strips. Wait for the paper to dry before painting.

4. After the painting process is finished, remove the watercolor tape. There are two ways to remove the tape, and depending on the type of painting, it is helpful to know both. Use a clean sponge to wet the tape, rubbing carefully along the tape surface. Try not to disturb your painting with stray drops of water since watercolor remains soluble even when dry. Once a strip of tape is moistened, begin to gently remove it from the paper by peeling and lifting a corner. If some of the tape sticks to the paper as you pull, wet the tape a little more and try again. The alternative to wetting and peeling the tape is to cut it. Use a straight-edge ruler and a craft knife to cut the tape completely away from the paper. You will be cutting off the extra paper margin that you allowed for when first preparing the paper.

5. If you don't have watercolor tape, don't let that prevent you from stretching paper when it's necessary. Instead you can use removable artists's tape, a low-tack painter's tape, or staple into a wooden board with a heavy-duty stapler. Since these other types of tape don't need to be moistened, you simply wet the paper as suggested above and adhere the paper to the board with the tape. You may need to encourage the tape to stick since it will want to resist the damp paper. If using a staple gun, place staples 2″ or 3″ (5.1 or 7.6 cm) apart.

To Flatten a Painting

It is possible to flatten a buckled or warped painting if you did not stretch it first. Lightly wet the backside of the paper with a clean flat brush or atomizer, making sure not to disturb the painting on the front. Place the paper face side down on a clean piece of Plexiglas which has a fine woven piece of cotton fabric on it. Lay another piece of cotton fabric over the painting and cover with a second piece of Plexiglas or a board. Add weight on top, such as several books, and let it rest and dry for at least an hour or up to a day or two. The pressure and weight will help to restore the paper to a near flat state.

PAINT

Traditionally, watercolor paintings are admired for relaying a sense of fluidity and for conveying lightness and color. The process of making a watercolor painting that evokes those sensations takes practice. A number of attempts may be made before one gets that "ah-ha" moment when it clicks. Perhaps that moment happens when layering a particular combination

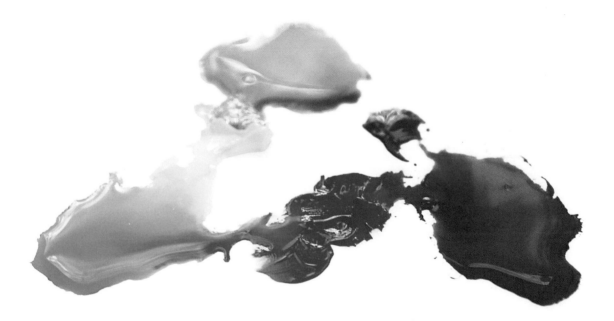

of colors turns out just right, when reserving the whites in the desired place finally happens, or when the combination of factors culminate in the making of the painting you imagined. Practice and experimentation with different types of watercolor may aid your explorations.

Types and History

Three types of watercolor are used in *Water Paper Paint*: tube, pan paint, and handmade watercolor. In most cases, any type is compatible with the projects, so simply use what you have. Good commercial paint is easily accessible; yet making your own paint by hand can be a simple and gratifying process.

Prior to the nineteenth century, artists had to make their own watercolor paint. It was a very laborious process to prepare for a painting session. Artists would have to grind hard dry clumps of pigment with water on a stone or ceramic slab, rubbing them into a usable consistency. Not until the late 18th century did paint come in a more soluble form. In 1766, William Reeves invented cake paint, which offered a much-improved paint for artists. He eventually developed the use of honey in the paint mixture that made the consistency more viscous and kept the paint moist. Those cakes were similar to the pan paints of today. Pans are typically small, square, or circular containers that hold individual dry colors. They are set together in a tray and are simply moistened with water during use. Their size and portability make them a suitable choice for working in the field or *en plein air*.

Seventy-five years after the invention of cake paint, John Goffe Rand patented the first metal paint tube in 1841. Then five years later, in 1846, Winsor & Newton developed a liquid watercolor formula and improved the design of Rand's tube. Since then, many manufacturers have adopted the screw top metal tube, and watercolor paint has become available to many. The tube keeps the paint creamy and smooth, a much wetter consistency than pan paint. While the pigment to vehicle ratio can vary today from 10 to 50 percent depending on the particular color, paint in tubes provides fine color and transparency. Because of the moisture content in tube paint, once it is squeezed onto the palette, a one-hour wait time is suggested before use.

MATERIALS

- dry pigments
- liquid gum arabic
- enamel or glass palette
- palette knife
- spoon
- pipette or eye dropper
- container for water
- fresh water (distilled water is preferred)
- cotton rag or paper towel
- protective gloves

Commercially made watercolors offer the best quality of paint. And while this is true, some artists like to make their own paint for more individual reasons. Making your own paint provides the opportunity to invent new color combinations and control the saturation or intensity. Some enjoy the simplicity of the raw materials and being involved in the hands-on process.

Watercolor is made of three basic ingredients: dry pigment, a binder (typically gum arabic), and water. Dry pigments and liquid (or powdered) gum arabic can be purchased from art suppliers. (See "Resources," on page 152.) Gum arabic is a sap harvested from the acacia tree and is light to medium amber in color. Gum arabic is the medium that binds the paint to the paper. It can also be added to store bought watercolor to prevent color bleeding in watery techniques and to add lustre to the paint surface.

The consistency of handmade paint is solid, similar to commercial pan color. Additionally, a humectant such as corn syrup or honey and a plasticizer like glycerin can be incorporated to help retain moisture or soften the paint. Store-bought paint may also include additional ingredients and fillers to improve the viscosity of the paint, make it more durable, and prolong its shelf life.

How to Make Watercolor by Hand

These instructions are an introduction to making watercolor by hand. They follow the simple method by which I was taught. If you want to pursue mixing paint, consult *The Painters Handbook: A Complete Reference* by Mark David Gottsegen for detailed information.

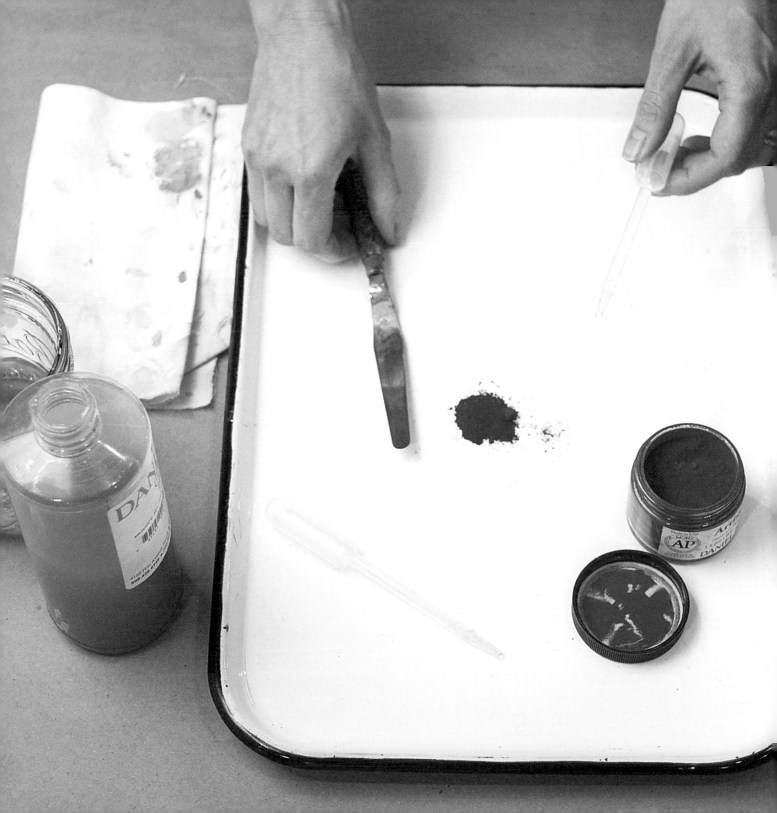

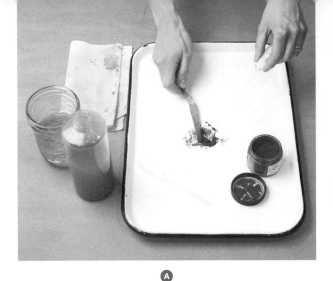

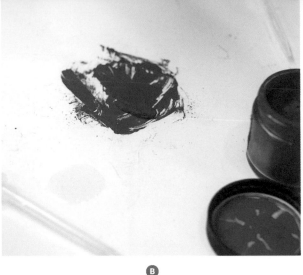

A

B

Process

1. Using a spoon, scoop 1 to 2 tablespoons (15 to 30 ml) of pigment onto a clean mixing area on the palette. Use an eyedropper to add a few drops of fresh or distilled water into the pigment. Grind with the flat side of a palette knife to disperse the pigment into the water until a paste forms. Some pigments accept water more readily than others. If the pigment becomes too dry during mixing, add a few more drops of water. If it becomes too wet, add more pigment *(fig. A)*.

2. Once the pigment is the consistency of toothpaste, add drops of gum arabic and mix together with the palette knife. Alternatively, a glass muller may be used for mixing. Handmade watercolor can be very opaque. Test the color on a scrap of watercolor paper and notice the color saturation. Increase the transparency if desired by adding gum arabic. Clean the mixing area and palette knife before mixing a new color *(fig. B)*.

3. Store handmade watercolor in small, lidded containers or on your palette. Before a painting session, dampen the watercolors by adding small droplets of water with a pipette, just as you would to commercial watercolor.

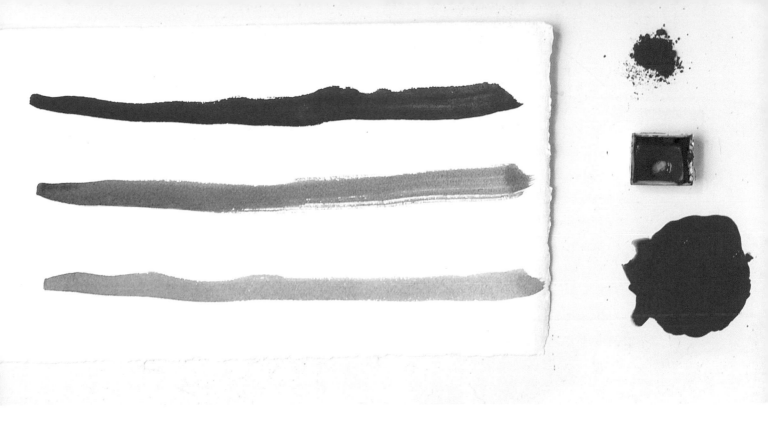

This sample shows color saturation with handmade watercolor *(top)*, pan watercolor *(middle)*, and tube watercolor *(bottom)*.

ADJUSTING THE RECIPE

1. If the paint does not want to adhere to the paper, then not enough gum arabic was used.

2. If the handmade watercolor is too hard or brittle, try adding a humectant. A drop or two of honey or corn syrup during the mixing process can help retain moisture. Use it sparingly because too much will make the paint sticky or cause it to mold over time.

3. If the paint is tough to dissolve, try adding small drops of glycerin during the mixing process.

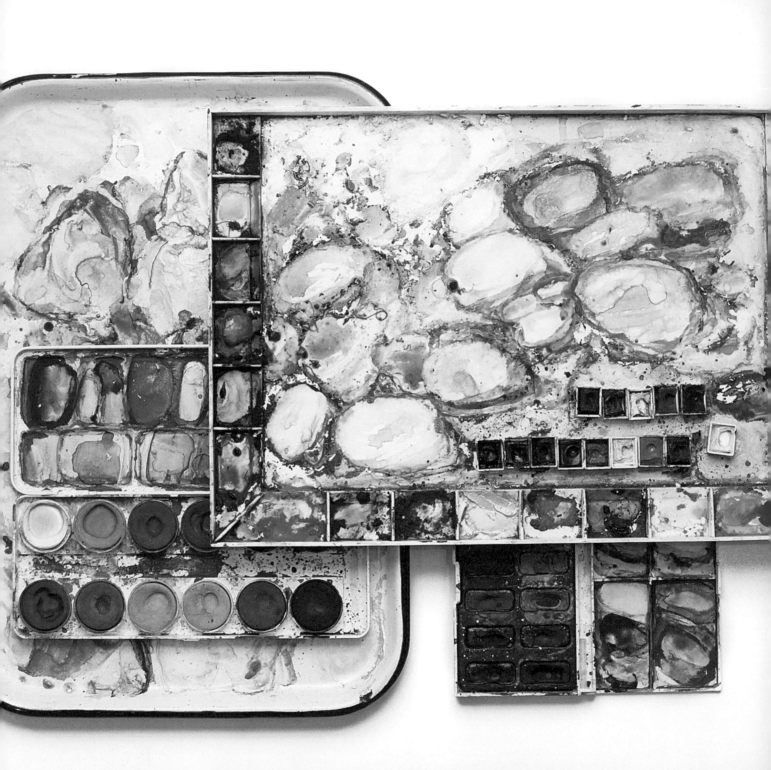

PALETTES

Palettes are the support on which artists mix paint and their preferred combination of colors. Where you paint can determine the type of palette or support you choose. When working in your own space, be it the studio, craft room, or on the dining room table, there are several options.

Types

A metal or enamel tray, a piece of Plexiglas, or even a piece of windshield or picture frame glass make good palettes and are economical. In your own space, you have the ability to set the palette on a worktable and not need to move it around. Enamel trays can be found from kitchen or restaurant suppliers and sometimes in thrift shops or flea markets. Glass and Plexiglas are easy to come by and give lots of mixing space. Make sure to bevel or tape the glass edges to prevent injury. When using a transparent palette, place a large sheet of white paper underneath to better see your colors. If you like to keep colors separate, try individual ceramic dishes or ramekins for storage and then mix colors on a large flat palette.

For fieldwork, something small and portable is favorable for toting to the location. Some tins or palettes come with the paint already supplied while other travel cases allow you to add your existing tube colors. Either way, a palette with a lid is necessary.

Most palettes available today have compartments for individual colors with separate open space for mixing. Whether you purchase a palette or utilize a support you already have, the surface you choose should be smooth, sturdy, and flat. One of my favorite palettes is an enamel baking tray that belonged to my grandmother. I use it for commercial watercolor as well as mixing my own paint with a palette knife. Within the open space, I let my color mixtures accumulate over time. Yet the surface is easy to clean when I am ready to mix a fresh palette.

Color and Paint Labels

Paint selection in stores can be both mesmerizing and daunting with hundreds of colors from which to choose. Starting with too few colors can limit your mixing possibilities while choosing too many is overwhelming and expensive. So before you buy an unnecessary amount, it is good to know a few things about color and paint cataloging.

Color is described by three characteristics; color, value, and chroma. Color refers to the hue or name, such as red, yellow, or blue. Value, or lightness, describes how a color is light, dark, or somewhere in between on the value scale. And chroma refers to the concentration or purity of color, whether it is dull or intense. Paint used directly from the tube is more concentrated than paint diluted with water or tinted.

Each color of watercolor, and others paints as well, have names conceived by manufacturers. Names like "Monte Amiata Natural Sienna" and "Pompeii Red" stamped on the labels sound beautiful and appealing. Yet these terms do not necessarily tell you what mixture is inside. It is helpful to read the individual pigments listed on the tube or pan label. Both of the colors mentioned above contain the same pigment, PBr 7. That combination of letters and numbers is a universal system called the Colour Index International and is used by manufacturers to identify colors. In this example, *P* means it is a pigment rather than a dye, *Br* refers to its general hue, which is brown in this case, and *7* is its assigned number. With the hundreds of color choices available, some colors you like may be duplicates in disguise that are made from the same raw pigments.

Other information noted on labels is the lightfastness rating. Lightfastness refers to how durable the paint is over time when exposed to sunlight. Various manufacturers have different nomenclature to describe these ratings. Colors with excellent resistance are extremely permanent. Colors with very good resistance are durable with good resistance to light. These ratings mean that these colors have proven through testing to be very strong and long lasting and won't fade, discolor, or become opaque. Fair or fugitive ratings indicate that the color could be less stable and deteriorate when exposed unprotected for long periods of time to bright light. Fugitive paint could deteriorate within a year's time. Artist or professional and student grade paint alike should have a rating system on the tube packaging. Choose what you can afford with knowledge of the ratings and what they mean.

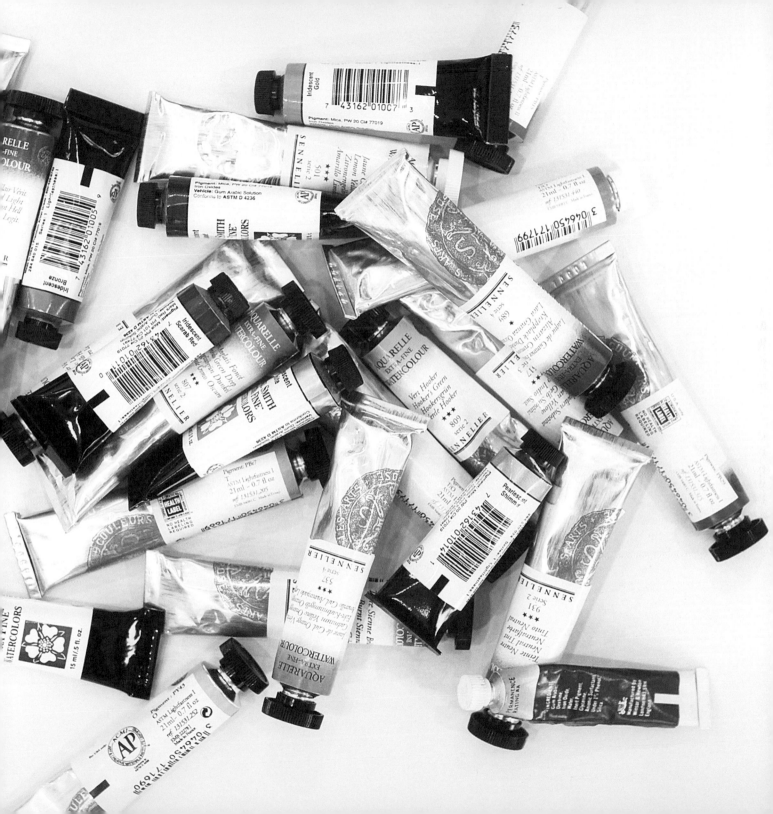

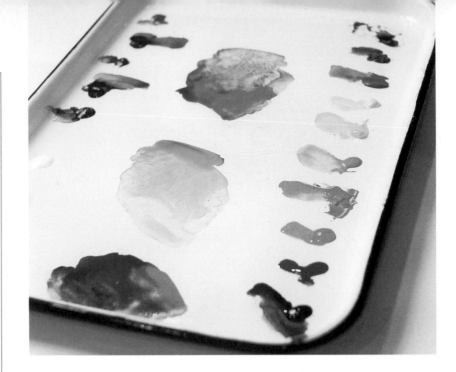

Paint Color Suggestions

- Quinacridone Magenta or Alizarin Crimson
- Cadmium Red Light
- Cadmium Yellow Orange, optional
- Yellow Ochre
- Indian Yellow
- Cadmium Yellow Light
- Lemon Yellow
- Raw Umber
- Burnt Sienna
- Sepia
- Hookers Green, optional
- Phthalo Green
- Ultramarine Deep
- Cerulean Blue
- Phthalo Blue
- Indigo, optional
- Chinese White
- Neutral Tint

(See "Picking and Choosing," page 27.)

Arranging a Palette

How many colors do you really need to set up a palette? Select a dozen or so colors that offer variety and a broad mixing range within each hue. Arranging the paint colors on the palette in a particular order helps you know where they are and find them easily while working. Generally, artists arrange the colors so they are in a spectrum, but you may find a way that works better for you. Having an organized palette can help someone beginning in watercolor see relationships between colors and values. Specific color choices should be based on individual preferences and traditions, but here is a suggested list (shown, left) to get started.

Color Systems

MONOCHROMATIC

A monochromatic color system is made of one color, white, and black, with a wide range of values and intensities. With watercolor, values can be achieved also by layering thin washes of color to make it appear light or dark.

PRIMARY

A primary color system uses the three primary colors to organize the painting: red, yellow, and blue.

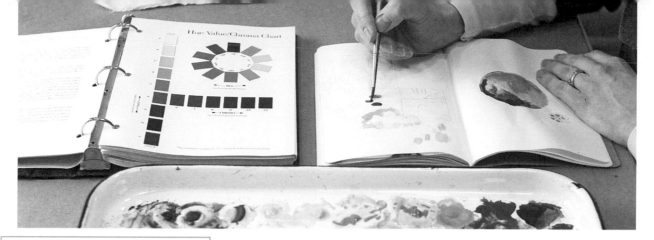

Picking and Choosing

When comparing Quinacridone Magenta and Alizarin Crimson, the former is more lightfast but can be more expensive than the latter. If you want to incorporate a soft blue, consider Cerulean Blue. For purchasing on a budget, you could omit Indigo and use the Neutral Tint in its stead; omit Cadmium Yellow Orange and Hookers Green and choose either Burnt Sienna or Sepia. While Chinese White is not absolutely necessary for tinting a color, if you are used to working with oil or acrylic paint, using a small bit of white may ease you into watercolor mixing techniques.

SECONDARY

Mixing two primary colors together make secondary colors. Red and yellow makes orange, yellow and blue makes green, and blue and red makes violet. A secondary color system uses orange, green, and violet.

TERTIARY

Mixing a primary color with a secondary color next to it makes tertiary colors. The tertiary colors are red-orange, yellow-orange, yellow-green, blue-green, blue-violet, and red-violet.

COMPLEMENTARY

Complementary colors are those directly across from one another on the color wheel. Blue and orange, red and green, and yellow and violet are color complements. Pairing a color with its opposite creates a dynamic contrast.

SPLIT COMPLEMENTARY

A split complementary system is made of three colors: a color plus the two colors next to its complement. For instance, yellow, blue-violet, and red-violet would make a split complementary system.

DOUBLE SPLIT COMPLEMENTARY

A double split complementary system is made of four colors. It is made of two pairs of color complements. Blue, orange, violet, and yellow form such a system.

BRUSHES

The paintbrush is an indispensable tool to distribute paint to the paper and communicate your thoughts and ideas. There are about a half dozen common types available in sizes from small to large. Knowing about brush composition, types, and sizes can help you choose the brushes to suit your needs.

Brush types (left to right): examples of wash, flat, angle, script, and round brushes

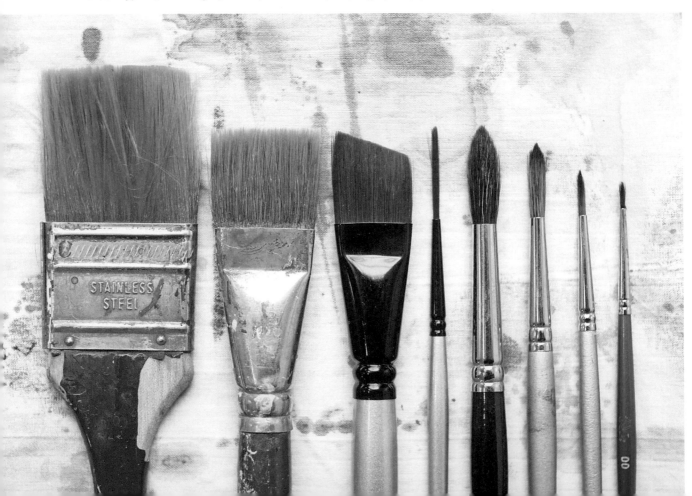

Brush Composition

A brush is made of three parts; the tuft, ferrule, and handle. The tuft, or bristle, are the hairs that can be of either synthetic or natural origin. They are tied together and glued inside the metal ferrule. The metal ferrule shapes and supports the tuft. It also helps keep water from destroying the glue that holds all the hairs in place. The handle is the part you hold and is made of wood coated with lacquer. The shape is wide near the ferrule and tapers to a point at the end. It is most comfortable to hold the brush near or just behind the thickest part of the handle.

The hairs used in brush tufts can be from natural sources or made of synthetic material. Natural hair is harvested from animals like mongoose, squirrel, and sable or from hair in the ears of ox and pigs. Natural fiber brushes hold paint well and make soft continuous strokes. For centuries, sable brushes have been prized because of their fine quality and durability, and they are also the most expensive. Synthetic nylon is an alternative to animal hair. Synthetic brushes continue to improve in quality and offer an affordable alternative to sable. A good watercolor brush, whether natural or synthetic, needs to be soft and flexible and able to hold and distribute paint fluidly.

Types

A wash brush is similar to a flat brush but has a different shape handle, resembling something like a hardware store-variety utility brush. The sizes are larger than flats and are measured in inches. Wash brushes are good for distributing large amounts of paint or water to an area.

A flat brush has ferrules that hold the tuft horizontally, forming a row of hairs. Depending on how the brush is held, the flat side can make a broad wash and the narrow edge of the tuft can make thin or thick lines.

An angle brush is comfortable to use. It resembles a flat brush in ferrule structure but with a slope or angle at the tips of the tuft.

A script brush looks like a small round brush, but it has longer tuft. It is useful for delicate line work or writing with watercolor. A regular round brush would make a fine substitute.

A round brush has a round ferrule and bristles that form a point at the tip. A round brush is one of the most flexible watercolor brushes as it can make broad washes when the belly of the bristles is pressed to the paper but also fine lines when the tip delicately scrapes the paper.

Other useful brushes that are not shown in the photo on page 28 are mop, filbert, fan, and acrylic brushes. A mop brush is a soft, natural-hair brush and is traditionally wrapped with wire around the base of the bristles. Mop brushes hold a lot of water and are good for wetting paper. A filbert brush is flat with hairs tapering in an oval shape at the tuft end. A fan brush has hairs arranged like a fan and is useful for making textural marks. An acrylic brush is a flat brush with a clear acrylic handle and synthetic bristles. The handle has an angled tip that can be used to burnish or rub paper.

Sizes

Brushes are sized with a series of numbers ranging from 000 (very small) to 24 (very large). Oftentimes flat brushes and wash brushes are measured in inches, 1 1/2″ (38 mm), 1″ (25 mm), 3/4″ (19 mm), 1/2″ (13 mm), and so on. With both measuring systems, the numbers are visibly marked on the brush handle. Artists are inclined to have favorite kinds and sizes of brushes based on the scale and approach of their work. My preferences include a range of round brushes from sizes 00 to 14, as well as a few flats and a large wash brush. If you are buying brushes for the first time, here (shown, left) is a suggested selection to get started. Try both synthetic and natural bristle brushes to see which you prefer. And remember the sizes you need are partly determined by the scale of your work.

Brush Care

Following a few common sense tips can help you maintain the life of your brushes. Synthetic brushes are generally inexpensive enough that if one becomes ruined, it is easily replaced. Sable brushes, however, can cost anywhere from $15 to over $400 per brush depending on its size. Nevertheless, brushes of any kind are an investment, and these practices will help prolong their life.

Brushes should never be left standing on their bristles, whether they are dry or in a jar of water. Doing so will bend the bristles and cause them to become permanently warped. While you are working, keep the brushes you are using flat on the table.

When a work session is over, rinse brushes thoroughly in clean water. Then wash in lukewarm water and use a glycerin or mild vegetable-based soap to remove paint. Some pigments stain the brushes easily. Using a little soap will help remove the paint that gathers in the tuft. Do not use hot water or detergent on brushes.

When rinsing brushes in water during work time or when washing, try to limit the amount of contact that water has above the ferrule. Water damages the glue hinge and can cause the lacquer handle to peel. Let clean brushes air dry on a flat surface rather than rubbing them with a towel.

Once brushes are dry, you can store them upright in containers. Once completely dry, natural hair and fine sable brushes can be stored in a sealed, plastic container to prevent damage by harmful insects and moths that eat the hairs. Never close a damp brush of any kind inside a sealed container.

Watercolor brushes should be reserved only for watercolor paint and not used in other paints or mediums. Do not use a good brush for masking fluid or any latex material. Only use an old or cheap brush for those purposes.

CHAPTER TWO:
PROJECTS

The projects in *Water Paper Paint* offer ideas and I hope inspiration. While not intending to influence a particular way of painting, they suggest examples that give evidence to the breadth of the medium. The projects range from very simple exercises to more complex compositions, yet all are accessible. The materials lists are suggestions, so feel free to adapt them as needed to what you have on hand. If you are picking up the brush for the first time, wet-into-wet painting and wet-onto-dry painting are satisfying places to begin. Some projects approach painting from life and imagination. Arrange a still life, draw from nature, and work from a photograph to strengthen drawing and compositional skills. Investigate new territories and express a creative voice. Incorporate water-soluble pencils, drip and squirt paint, and add salt to your work.

Embrace the painting process. While having a final project you can be proud of is gratifying, painting is a practice of discovery and realizing ideas. The experience of working with watercolor is fun, exploratory, and can be provocative. Yet such artistic challenges can give form to your original mark of beauty. During the process of painting, respond to that new beauty and bring it to light.

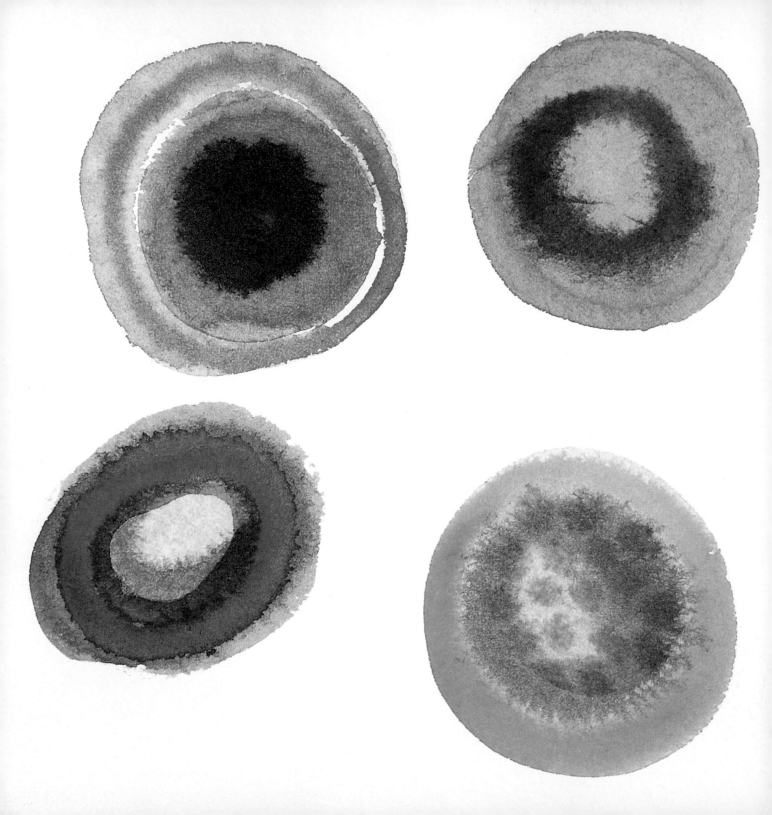

BASIC PAINTING:

WORKING WET INTO WET

MATERIALS

- round brushes sizes 4, 6, 8, and 10
- watercolor paints in tubes or pans
- sheet of rough 140 lb (300 gsm) paper, 7" x 7.5" (17.8 x 19.1 cm)
- pipette
- jars for water
- paper towel or fabric blotter
- palette

PAINT CONCENTRIC CIRCLES using layers of wet paint to experiment with color mixing, dilution levels, and simple pattern making.

The samples (at left) show four different color variations you could try: blue, monochromatic colors; green and blue, analogous colors; green and yellow, high intensity or bright colors; and red and green, complementary colors.

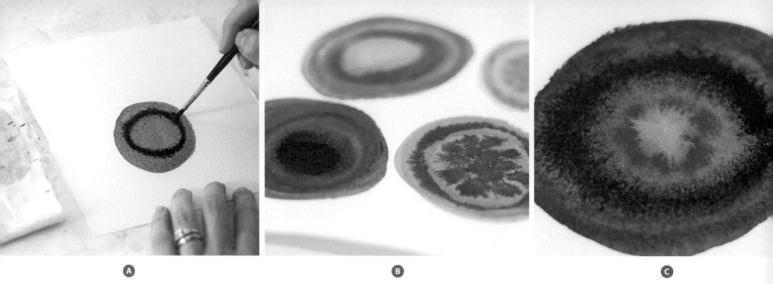

A

B

C

Tip

Consider the water to paint ratio. More water mixed with the color produces more transparent washes of color. Less water produces more intense, opaque washes.

Process

1. Before painting, dampen the watercolors by adding small drop-lets of water with a pipette. Choose the largest brush, wet it, dip it in moistened watercolor, and make simple circles or ovals on the paper using smooth, continuous movements. Make the brushstrokes at least 2″ to 3″ (5.1 to 7.6 cm) wide, giving room to play. Circles can be all the same color or different colors. Rinse the brush and pinch bristles gently to remove excess water.

2. Select a smaller brush to use next. While the circles are still wet, paint lines, dots, or other marks with another color into those wet areas *(fig. A)*.

3. Select a smaller brush and add a contrasting color, still working into the wet paint. While painting in the wet areas, it is important to notice the way the color of each layer spreads outward, forming small arteries of paint. Also notice how each new color layer mixes with the prior layers of paint. For instance, what happens when yel-low is painted onto blue? The two primary colors will make green; an alternative to using green straight from a tube. You may also dis-cover how it is easy to make brown when red is added to green as multiple layers of wet paint blend. It may sound elementary, but it is good to see the process happen *(figs. B and C)*.

Make Something!

This project can be made into tags by using a circular paper punch to cut the painting into cards. Loop with a string and attach to a gift, adding a personal touch.

BASIC PAINTING:
WORKING WET ONTO DRY

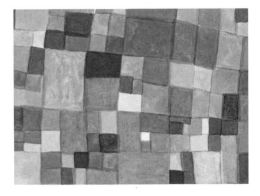

A

PAINT A GEOMETRIC SQUARE pattern and layer bright colors onto neutral tones. This is a useful project for the beginner who wants to practice color mixing and see how colors change. It is also a fun exploration for the advanced artist to work with layers of color and pattern.

Process

1. Cut or tear the watercolor paper to size. Stretch and adhere the paper to a wooden or fiber board support as described on page 14.

2. Moisten the watercolors slightly by either dropping a small drop of water on them with a pipette or by dabbing gently with a wet brush. Select the number 6 or 8 brush and start with a neutral color like yellow ochre. Begin mixing the color on a clean portion of the palette with enough space for further mixing. Once the ochre is mixed, saturate the brush with the color and dab once lightly on a blotter to remove excess paint. Paint a rectangle approximately 1" (2.5 cm) in size near the middle of the paper. Begin by painting the edges of the rectangle using the tip of the brush. Then fill in the shape evenly with the side of the bristles and by moving the brush up and down and back and forth. The brush should be saturated enough to paint the entire shape without recharging *(fig. A)*.

3. Select another color like yellow or green and add a tiny amount to the existing yellow ochre on the palette. Be aware that only a tiny amount of color is needed to change the hue of the original yellow ochre color. With the new color, paint a second square near the first

MATERIALS

- low-tack painters tape
- round brushes sizes 4, 6, and 8
- watercolor paints in tubes or pans
- piece of 140 lb (300 gsm) hot-press watercolor paper, 10" x 10" (25.4 x 25.4 cm)
- jars for water
- paper towel or fabric blotter
- palette

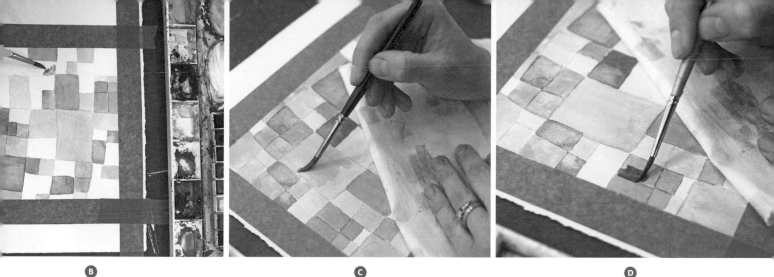

B

C

D

Considerations

Notice how the colors vary in intensity depending on how much color is added to the original yellow ochre base color. Also notice how a color can be neutralized with the addition of its color complement or color opposite on the color wheel. For instance, yellow and violet are complements, as are blue and orange and red and green.

Tip

Make sure each corner of the painting composition has a different size or color of square. This will help create a more interesting composition and lead the eye around the piece.

square. Make sure the edges are not touching so the colors don't bleed into each other. Use the blotter to dab excess paint from the first painted square to prevent pooling.

4. Continue the process of adding a fresh color to the mixing area so the color is building. The changes may be subtle. Be aware that only a tiny amount of color is necessary to change the hue of the original ochre color. Paint a new square or rectangle with each new color mixture *(fig. B)*.

5. While painting the squares, vary their sizes while also changing brush sizes as needed. It is efficient to use a size 8 brush to paint a large square, and a number 4 brush can be more accurate when painting a small square. Paint the entire paper completely with squares and rectangles. The shapes will be almost touching, edge to edge.

6. When the paint is dry, add another layer to the painting. When painting the second layer of squares, use more pure hues such as yellow, red, and blue in transparent washes *(fig. C)*. Notice how the initial colors appear darker when new hues are added on top *(fig. D)*. Painting over all the squares is not necessary, but it is perfectly fine to do. You may also want to try combining squares into larger shapes by painting over the edges. Continue painting until the color and value appears balanced in the painting. When you are finished, carefully remove the tape from the paper to see the final painting.

COLOR WHEEL

1 . 2 . 3 .
6 . 5 . 4 . = {ALWAYS}
7 . 8 . 9 . PLANT
 POSITIVE
 WORDS

TEXTURE AND PATTERN:
DABBING WITH DIFFERENT MATERIALS

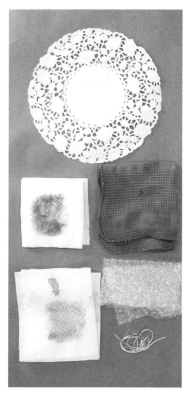

A

MATERIALS

- paper towel
- cotton muslin
- toilet paper
- bubble wrap
- clean, cotton dishrag
- paper doily
- cotton thread
- low-tack painters or artists tape
- straight-edge ruler
- wood or fiber board, larger than paper size
- round brushes sizes 0, 2, 4, 6, and 8
- watercolor paints in tubes or pans
- scrap watercolor paper
- piece of 140 lb (300 gsm) hot-press watercolor paper, 8" x 11" (20.3 x 27.9 cm)
- jars for water
- palette

PAINT AND DAB different household materials onto wet paint and explore how texture can enliven a painting.

Process

1. Collect different materials from the list to use for texture making and feel free to add more than the ones suggested *(fig. A)*. Other possibilities include plastic mesh, bath scrubs, loofah, cotton balls, or other absorbent materials. On the scrap watercolor paper, test the materials before beginning the final painting *(fig. B, page 42)*. With a large brush and a vibrant color, paint a section on the paper. Make sure the watercolor is neither too wet nor too dry. The paint on the paper should have sheen and reflect light. Test one of the materials by placing it onto the wet paint and press lightly. Lift it up gently and see the texture. Part of the paint will be absorbed or displaced by the material. Continue testing each of the other materials one at a time, determining which you like best. Some materials make dramatic textures while others are subtle. Both can be useful.

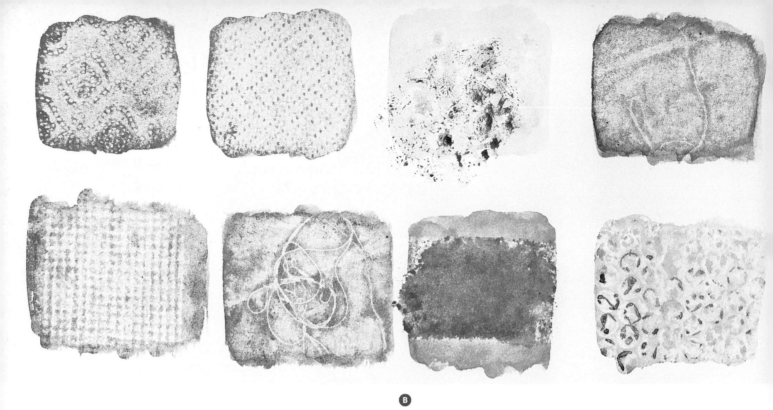

Texture samples *(top left to bottom right)*: toilet paper, paper towel, paper doily, cotton muslin, cotton-wove dishtowel, thread, Styrofoam, and bubble wrap

2. Cut or tear the watercolor paper to size. Using a ruler, measure a 5" x 7" (12.7 x 17.8 cm) image area and draw the frame lines lightly on the paper with pencil. Use low-tack painter's tape to secure the edges around the image area. This makes a clean edge on the finished painting.

3. Begin the piece by drawing your ideas in pencil. Consider combining representational objects, abstract ideas, and writing in all quadrants of the paper. The drawing may be a visible element in the final piece. When you have finished drawing, mix several colors in light and medium values on the palette. Paint the background in washes *(fig. C)*. Work quickly and paint several color swatches next to and overlapping one another. While the paint is wet, choose one of the dabbing materials such as bubble wrap. Let the bubble wrap or other plastics dry on the paper before lifting them up. If needed, weight the plastic slightly while drying *(fig. D)*. Next, experiment with a

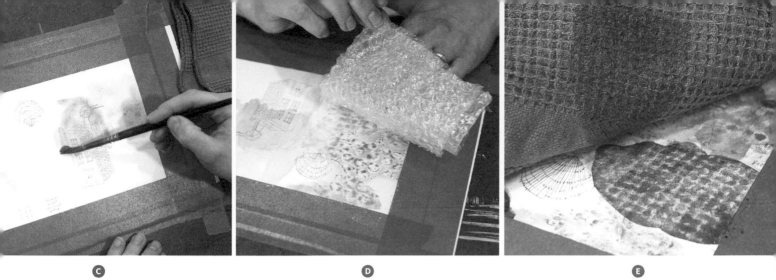

C D E

Tip

If the impressions are lighter than desired, try painting the textured material and press it on the paper to help darken or accentuate the texture. Bubble wrap and string print well using this method.

paper towel or cotton dishrag and press it into the wet paint *(fig. E)*. Press it down firmly and lift it up to make a clean impression. Continue painting the background, changing colors and dabbing different materials throughout. (The background of the project example on page 40 used paper towel, toilet paper, cotton dishrag, and bubble wrap textures.)

4. After the background is painted and dry, begin working on the middle and foreground. Try painting a dark area, such as the dark blues near the top of the project example, and press the cotton thread into the paint. If the string impression doesn't show as much as you would like, wait until it is dry and try painting and dabbing again using either a deeper blue or a different color. It is possible to layer colors by painting and dabbing with each layer. To achieve the most contrast, use a new color on top.

5. Keep in mind that not all elements of the painting need to use the paint and dab method. Consider incorporating drawing and writing, glazing layers of paint, such as in the shell of the project example, and painting fine lines to add detail and interest to the piece. When you are finished, carefully remove the tape from the paper to see the final painting.

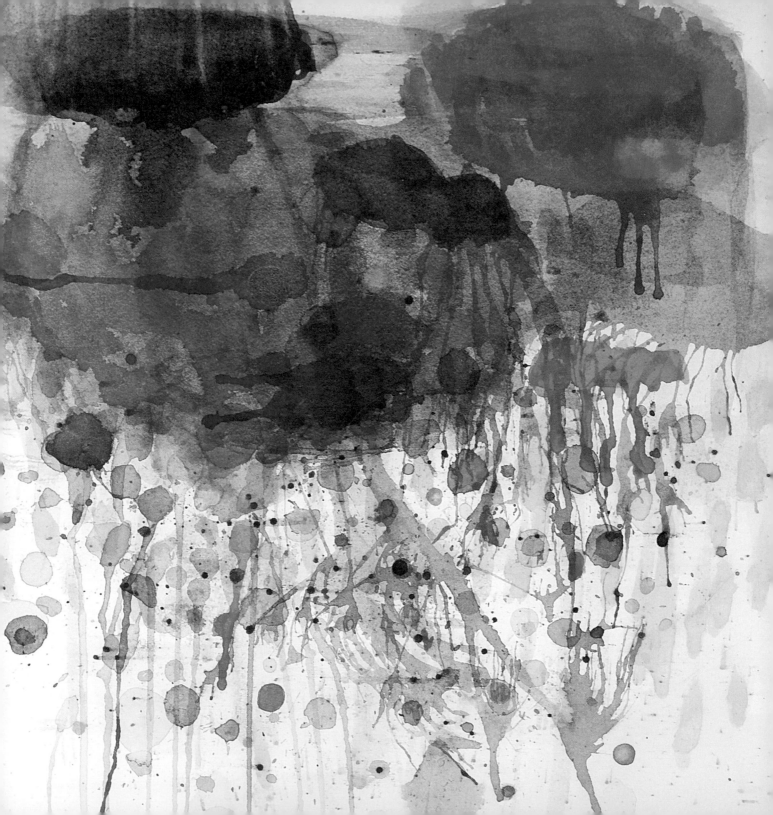

EXPLORATIONS:

DRIPPING, BLOWING, SPLATTERING, AND SQUIRTING PAINT

MATERIALS

- pipettes
- flexible drinking straw
- scrap wedge of cardboard or mat board
- wood or fiber board, larger than paper size
- round brushes of any size
- watercolor paints in tubes
- piece of 140 lb (300 gsm) cold or hot-press watercolor paper, 11" x 14" (27.9 x 35.6 cm)
- jars for water
- paper towel or fabric blotter
- palette

EXPLORE PLAYFUL WAYS to apply watercolor to paper by dripping, blowing, splattering, squirting, and smearing the paint. Make textures and create interesting surface qualities. This project may make you feel like a kid again!

Process

1. *Preparation:* If desired, stretch the paper and adhere to a wooden or fiber board support as described on page 14. Whether the paper is loose or attached, you need to be able to tilt the paper for some of the methods discussed. Prepare a clean space on the palette for mixing large color pools.

2. *Scraping Paint:* Turn the paper vertically and use a large clean brush to dampen the upper third of the paper with fresh water. Charge a size 8 or 6 round brush with color and make thick vertical lines or stripes within the wet area. The primary colors, red, yellow, blue will work well *(fig. A, page 46)*. Then use the side of a wedge of cardboard or mat board to scrape across the stripes horizontally, blending them together *(fig. B, page 46)*. Move once across and back rather than going over and over to help keep the colors pure. If excess paint builds on the wedge, dab it on a paper towel or blotter. Before the paint dries, select a few darker colors to repeat the painting and scraping method. The paint may extend completely from the left to right side of the paper. This approach blends colors and creates the appearance of a smooth surface.

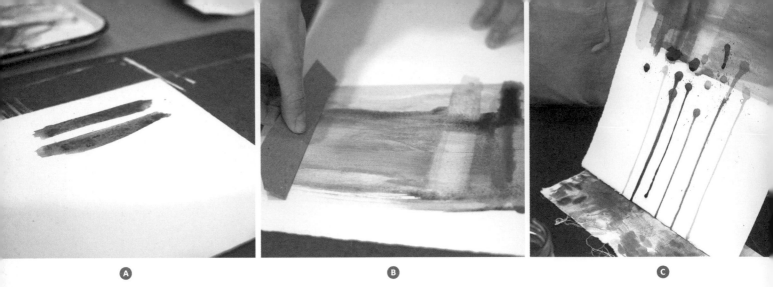

A

B

C

3. *Squirting and Dripping:* Mix a few colors of your choice or more of what was used in the first step. Make a good-sized puddle of those colors in a clean spot on the palette, adding water to dilute and give volume. Use a pipette to drink up a bit of one of the colors and squirt it onto the paper below the scraped area. Make a number of squirts and repeat using the other prepared colors. Work somewhat quickly so the paint remains wet. Tilt the paper so large paint drops will flow down the paper on their own *(fig. C)*.

4. *Squirting:* Try squirting various amounts of paint. Let the colors dry on their own and maintain the inherent circular shape to contrast the drips and lines.

5. *Splatter:* Making splatters is simple and fun. Hold a small number 2 or 4 brush charged with paint in one hand and tap the handle to release the paint *(fig. D)*. Try taking this one step further and make some larger splatters with a larger brush, such as a size 6, and then use the cardboard to scrape over the splatters.

6. *Squirting and Blowing:* Make several large dark shapes and let the paint puddle slightly on the paper. Use a flexible drinking straw and blow into one puddle at a time. Notice you will be able to guide the direction of the branchlike lines that form by turning the straw *(fig. E)*.

7. This painting combines many different approaches to making textures and applying the watercolor. After experimenting and layering them all, look at the piece from a distance. Decide if there are techniques you would like to repeat. Which ones may help complete the painting? Are larger shapes needed to stabilize the painting composition? Could adding intense and dark colors create depth in the painting?

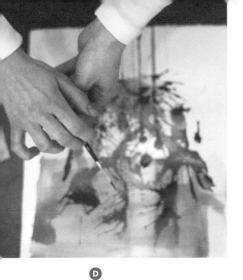

D

Taking it Further

Try adding collage items, painting bold shapes, or incorporating drawing to bring contrast and interest to the piece.

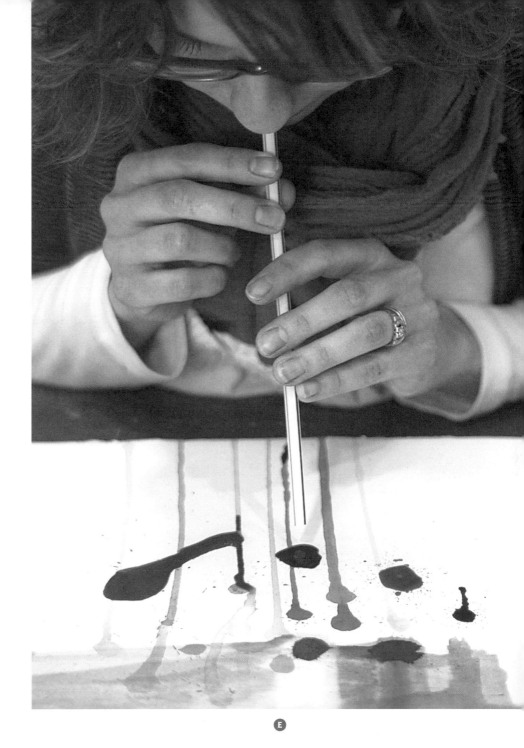

E

BRUSHES:

MAKING MARKS WITH ONE OR MANY

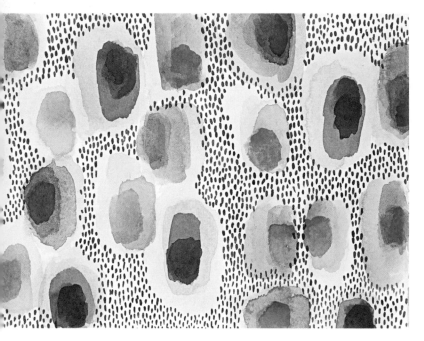

EXPLORE MARK MAKING in watercolor by using brushes in a range of sizes and by repeating marks with only one.

Process

1. Cut or tear the watercolor paper to size. If desired, stretch the paper and adhere to a wooden or fiber board support as described on page 14. If you don't stretch the paper first, it will buckle; however, it can be flattened out when the painting is finished and dry. Directions for flattening a painting are in the Basics chapter, page 15.

2. With the number 12 brush or largest brush available, make large oval shapes on the paper. Use one color at a time and make three to five shapes evenly spaced across the paper. Add a good amount of water to the color so the paint will appear light on the paper. You will begin with light colors and tints, and as the piece progresses, the colors will become darker and more intense. Next, select another color and make several more shapes. Continue adding more color shapes with the same large brush until the paper is filled with shapes with some white crevices of paper showing (*fig. A*).

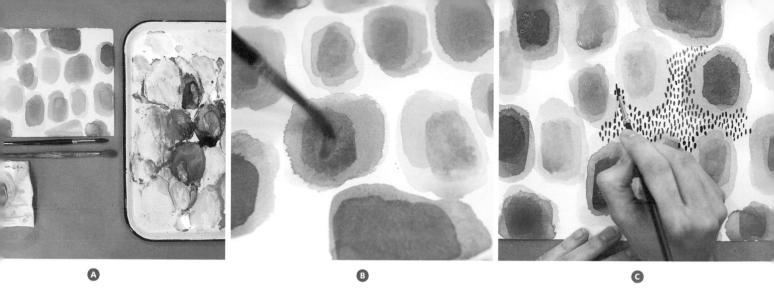

A

B

C

MATERIALS

- round brushes sizes 2, 4, 6, 8, 10, and 12
- watercolor paints in tubes or pans
- hot-press or cold-press watercolor paper, 8" x 11" (20.3 x 27.9 cm)
- jars for water
- paper towel or fabric blotter
- palette

3. For the next layer, mix colors within the same hues as the first shapes that were painted. Vary them slightly by making them darker or brighter. Using a smaller brush, such as a size 10, paint dabs, ovals, or marks onto the previous colors. Layer colors of the same hue; paint bright oranges on top of light oranges and dark blues on top of light blues. In this process, you are building depth and color by repeating marks *(fig. B)*.

4. Continue next with an 8 brush and then a 6 brush. As in step three, mix colors of the same hue and increase the intensity or deepen the value of the color. Layer smaller marks on top of the first two layers. Try to have at least four to five layers before moving to the next phase.

5. With the number 2 brush and black paint, make a pattern of small dashes or lines in the negative spaces *(fig. C)*. Allow the marks to overlap the edges of the colors if desired. Continue across the entire painting. Notice the contrast of these small repeating marks among the large marks of color. There may be times in future works where you desire to make a pattern painted with one brush. This project or exercise will help you determine when it may be valuable to paint an area with multiple brushes or to use just one size.

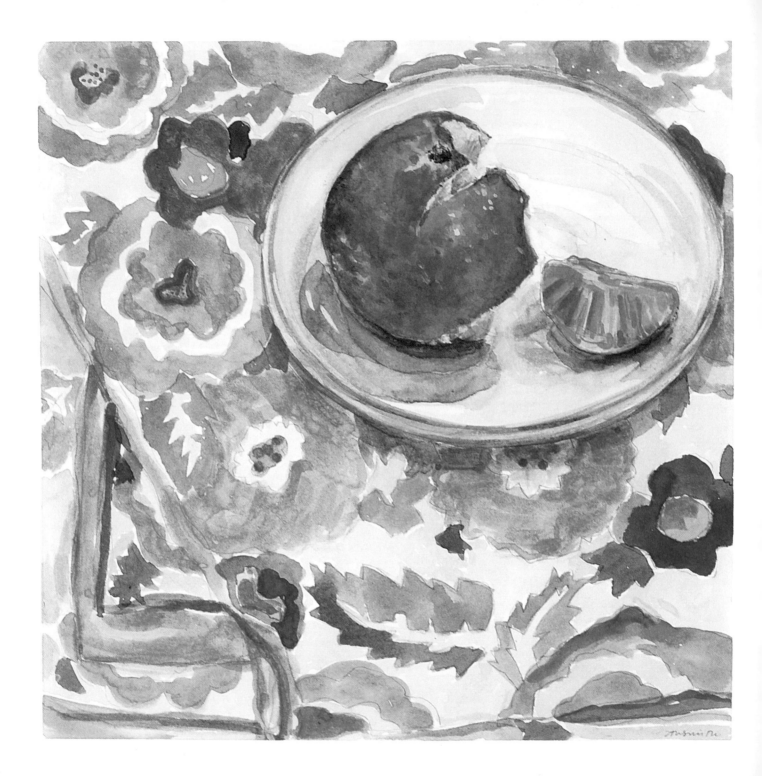

Palettes:

USING A COLOR SYSTEM

LEARN HOW a color system can help organize a composition. Unify the painting by creating color, harmony, or contrast.

Process

1. Cut or tear the watercolor paper to size. Using a ruler, measure an 8" x 8" (20.3 x 20.3 cm) image area and draw the frame lines lightly on the paper with pencil. Stretch and adhere the paper to a wooden or fiber board support as instructed on page 14.

2. Select a color system, such as primary, tertiary, or complementary, as described in the Basics chapter, page 27. (The project example uses complementary colors.)

3. Choose two or three objects that incorporate the chosen colors and arrange a simple still life. Keep the arrangement minimal: an object and an interesting ground, as this is more a study in color rather than one about making an elaborate set up.

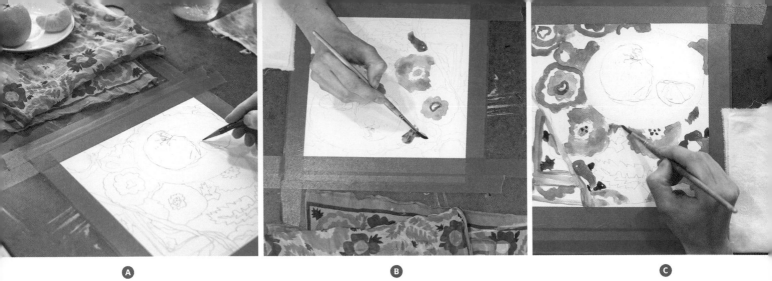

A B C

Tip

When choosing still-life objects, consider choosing one that is inherently white. It will help you see shadows and color reflections from other objects.

4. On the prepared paper, draw the composition in contour lines. Note the objects, ground, patterns, texture changes, and shadow shapes *(fig. A)*. When you have enough information drawn to know where items are located, begin preparing the paint. Moisten the tube colors with a pipette of fresh water and make a clean space on the palette for color mixing. Begin with the ground of the still life and mix the predominant or largest colors found *(fig. B)*. Work across the entire ground before moving to the actual objects. Use a size 8 or 6 brush to paint the shapes with several colors. Make loose brushstrokes without worrying about putting everything in just the right place. Let the paint flow, showing the integrity of the brush marks *(fig. C)*.

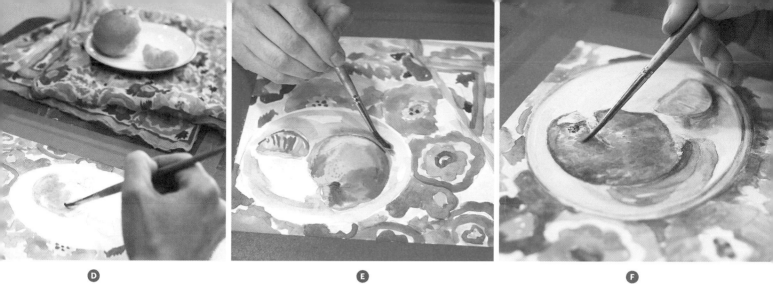

D

E

F

5. Once the ground is suggested, begin mixing the colors of the objects. To show highlights on a shiny surface, remember to keep the white of the paper visible *(fig. D)*. Then consider working wet on dry by glazing diluted washes over one another to create the shadows *(fig. E)*. Try thin mixtures of neutral tint, browns, blacks, and local colors to paint the shadows and reflections.

6. Consider the contrast of colors in this project and how to paint the objects in different ways. Try painting an object with smaller marks and shadows to contrast the movement and flatness of the colors in the ground. Noticing the way light and shadows reflect on and around the objects will help make the objects appear three-dimensional. Then add details of intense color and fine lines in areas to note specific information or texture *(fig. F)*. Finally, use white and tints to return any lost highlights to the form. When you are finished, carefully remove the tape from the paper to see the final painting.

MEDIUMS:

USING SALT
TO MAKE TEXTURE

MATERIALS

- table salt
- 1" (25 mm) flat brush
- round brushes sizes 6, 8, or larger
- watercolor paints in pans or tubes
- piece of 140 lb (300 gsm) cold- or hot-press watercolor paper, 8" x 9" (20.3 x 22.9 cm)
- jars for water
- paper towel or fabric blotter
- palette

A B C

TAKING ITS INSPIRATION from salt glazing in ceramics, this project explores adding salt to watercolor to make texture.

Process

1. Begin by dipping the 1" (25 mm) flat brush in clean water and dampen the entire paper surface by making broad strokes back and forth. Before the paper dries, select a dark color (such as blue in the project sample). Make a shape in the middle of the paper using a size 8 brush or whatever size you have on hand. Select another color or a different blue to add to the first blue. Continue making simple, loose marks, watching how the paint spreads on the wet paper and blends with the previous color. Finally add black, or a darker color of your choice. Paint these layers somewhat quickly because the next step requires the paint to be wet *(fig. A)*.

2. Finding the right time to add salt to the painted area is key. The paint on the paper should be wet and have sheen to it, but it should not have puddles. If the paint on the paper is too dry or wet, adding salt to the paint will not create the desired effect. When the paint moisture is at the magic moment, pinch a small amount of salt between your fingers and sprinkle it onto the paper *(fig. B)*. Less salt is better. The salt will visibly attract and absorb small amounts of paint and create a halo of light and dark *(fig. C)*.

3. Now, mix a contrasting color to paint around the central shape. Use a large round brush, such as size 8, and make a square or other shape around the central shape. Add more color by splattering dots of colors into it. Again, when the paint is at the magic moment, sprinkle salt around the square. When the painting is completely dry, brush the salt away.

4. While this project familiarizes you with the effect of adding salt to watercolor, there are many possibilities for applying this technique in other work. Try adding salt to make a textural ground in a still life painting or in a landscape, for example.

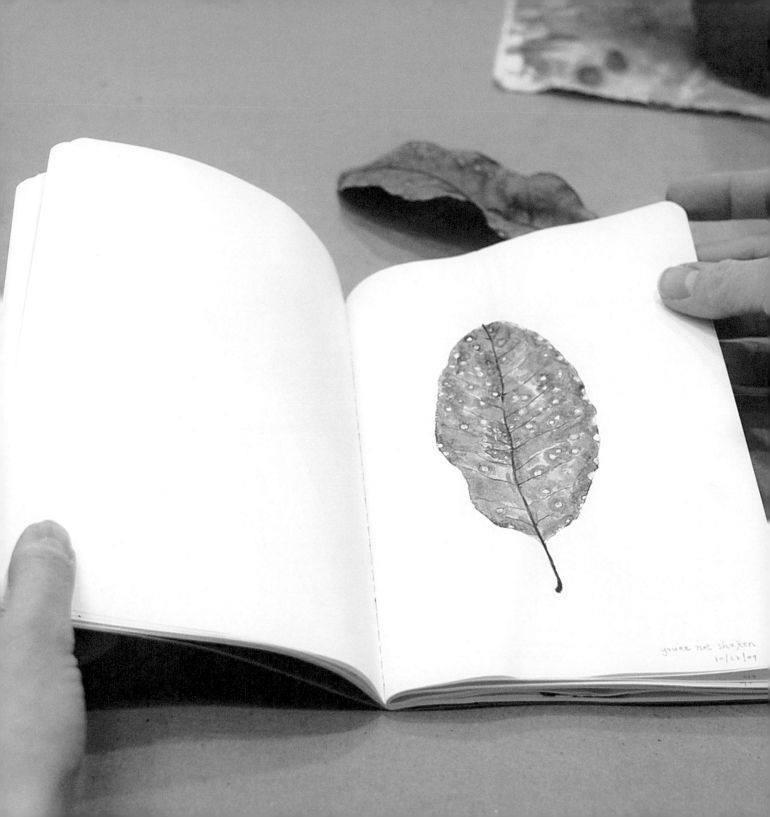

youre not shaken
10/27/09

PERSONAL SPACE:

KEEPING A SKETCHBOOK

MATERIALS

- sketchbook
- pencils
- round brushes of various sizes
- watercolor paints in pans or tubes
- jars for water
- paper towel or fabric blotter
- palette

INSPIRATION IS CAPRICIOUS and can spring forth unpredictably. Keeping a sketchbook provides a place to gather ideas and also a place to revisit your thoughts, observations, and writings.

Process

1. A sketchbook can serve a number of purposes: note observations found outside the home or studio; sketch ideas for larger work; and a place for personal study, to name a few. Sketchbooks come in all shapes, sizes, and paper content. Consider the type of materials you will explore. Different weights of paper, surface textures, and covers work best with certain media. Text-weight paper is suitable for graphite drawing and writing while cover-weight or heavier paper is good for receiving paint, glue, and collage. Hardbound covers provide a sturdy surface for working while softbound books work well for thematic study. Select a sketchbook that is comfortable to hold, has a weight of paper that you like, and is ultimately a journal you will actually use. Whenever possible select one made with acid free paper. You can also try making your own sketchbook. "Project 30" discusses how to make an artist's book.

2. Carry a sketchbook for observing the natural world, whether just walking around your neighborhood or traveling afar. Draw things that cannot be brought back to the studio. Having a sketchbook and pencil on hand when you're out and about enables you to take note whenever inspiration arises. These notations form a record of ideas, a chronological collection of thoughts over time, and may possibly contain concepts for your larger work. This collection becomes a place for you to visit during creative dry spells that inevitably arise. When you look back on what you have already made, it can encourage and inspire you to go forward.

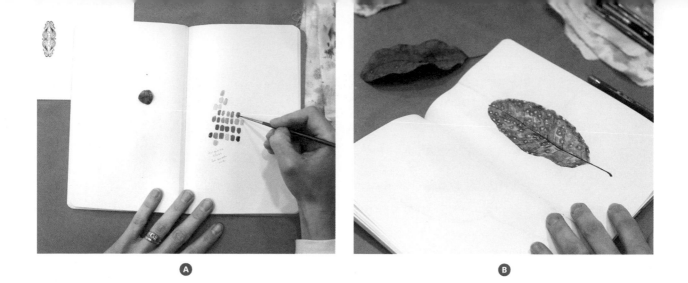

A

B

3. When working on large paintings, it is helpful to sketch ideas and solve problems in a place other than on the actual piece. Test color palettes, work out compositional questions, experiment with marks or textures, and try variations of the work within your sketchbook *(fig. A)*.

4. Perhaps you have a particular concept to explore or examine. The format of a sketchbook lets you consider an idea and build on it from page to page. Gather information and form a collection of observations or topical studies *(fig. B)*.

Write about or describe your drawings and discover the relationships between your written and visual components *(fig. C)*. Consider using a sketchbook as a pictorial or written journal. Work in it daily or regularly to get the most out of it. It may take a while to develop a habit of keeping a sketchbook, but do not get discouraged if you drop it for a while. Just review where you left off and return to it with new interest. Make your sketchbook your own and consider it a resource for understanding your growth as an artist and person.

geese
considering the
weight of stones sewn
and feathers
in their pockets of
..... calls gleaming
on us that a tumbling star?
..... before the moon

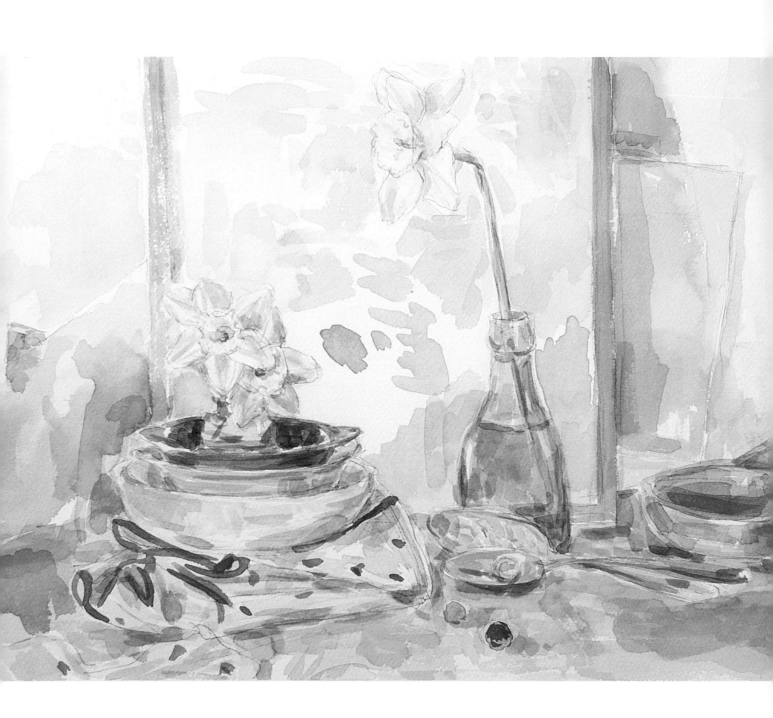

Painting From Life:

SETTING UP A STILL LIFE

MATERIALS

- objects for a still life
- clamp light
- viewfinder (refer to "Project 21" for instructions)
- H or HB pencil
- watercolor tape
- low-tack painter's tape
- flat brushes sizes $\frac{1}{2}$", $\frac{3}{4}$", and 1" (13, 19, and 25 mm)
- round brushes sizes 2, 4, 6, and 8
- watercolor in tubes or pans
- piece of cold-press paper cut to 16" x 22" (40.6 x 55.9 cm)
- jars for water
- paper towel or fabric blotter
- palette

WORKING FROM A CONTROLLED SUBJECT and light source, a still life affords you opportunities to paint over an extended period of time. This project is also a good chance to practice painting what and how you "see."

Process

1. Gather a number of objects that form a visual relationship or story. Choose inherently light and dark objects, those with a variety of colors, and incorporate items with different textures and surface qualities. As you arrange the items on a large tabletop or flat surface, elevate some objects to make a dynamic composition. Also try using fabric or paper to cover parts of the table and add more color. When everything is in place, set a clamp light to one side to create a direct light source *(fig. A, page 62)*.

2. Cut or tear the watercolor paper to size. Stretch and adhere the paper to a wooden or fiber board support as described on page 14. Using a ruler, measure a 12" x 16" (30.5 x 40.6 cm) image area and draw the frame lines lightly on the paper with pencil. Use low-tack painter's tape to secure the outside edges around the image area. This makes a clean edge on the finished painting.

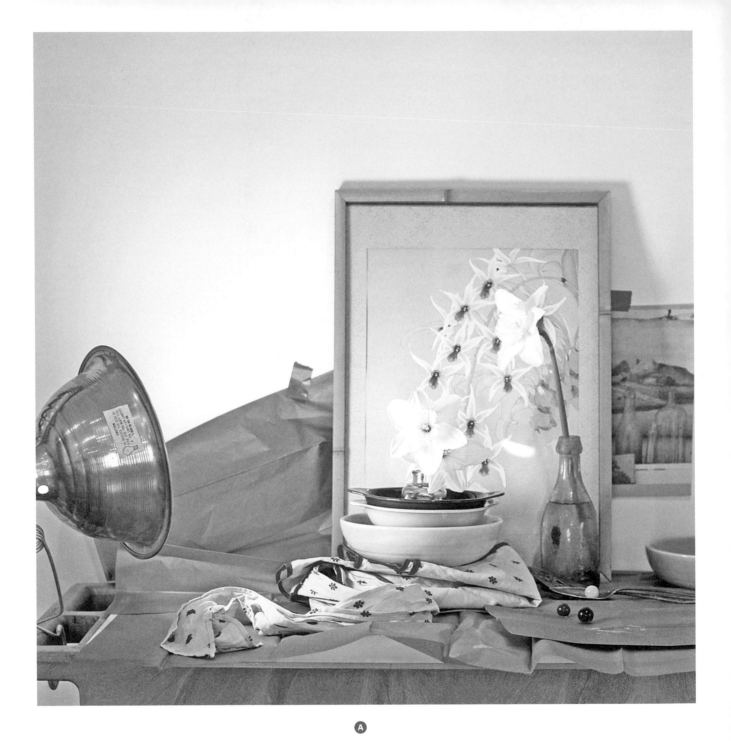

B

C

D

3. Prior to painting, think of a particular challenge you want to approach in this project. For instance, you may want to work spontaneously with the brush marks or maintain large portions of the white paper. It is also important to think about what inspires you in the composition you have arranged. What is the beauty or interest that you want to portray?

4. Use a viewfinder as you sketch the composition in pencil. To determine the placement of the items, draw light lines connecting the objects to gauge the space between parts of the composition. When working from life, look mostly at what is before you rather than at your paper *(fig. B)*. This helps you to see and also understand what you are seeing, making it less likely to contrive the painting.

5. Begin painting with a large round brush, such as a size 8, and a light color. Work quickly with the brush to show a sense of the gesture. Move organically all over the composition with additional colors and smaller brushes. Build layers in the light areas and then incorporate colors of middle value *(fig. C)*.

6. Add dark colors for depth and bright colors for emphasis. As you approach detailed areas, slow down for accuracy but try not to make tense brushstrokes *(fig. D)*.

COLOR:

USING HIGH-KEY OR LOW-KEY COLOR

MATERIALS

- painter's tape
- flat brushes sizes ¼″ and ½″ (6 and 13 mm)
- round brushes sizes 2, 4, 6, and 8
- watercolor in tubes or pans
- handmade watercolor (Refer to the Basics chapter for recipe and instructions.)
- 1 to 2 pieces cold-press paper, 11″ x 16″ (27.9 x 40.6 cm)
- jars for water
- paper towel or fabric blotter
- palette

PAINT WITH DIFFERENT LEVELS of color brightness and saturation and practice using opaque handmade watercolor in this project.

Process

1. Cut or tear the watercolor paper to size. Stretch the paper and adhere the paper to a wooden or fiber board support as described on page 14. Using a ruler, measure a 6″ x 9″ (15.2 x 22.9 cm) image area and draw the frame lines lightly on the paper with pencil. Use low-tack painter's tape to secure the outside edges around the image area. This makes a clean edge on the finished painting.

A

B

C

Considerations

Emphasize the movement of the shapes by balancing the amount and placement of low and highly saturated colors. Bright colors can lead the eye through a composition or add a "pop" of color in a small shape.

2. Color-key refers to brightness and color saturation. High-key is on the light end of the value gray scale, from middle gray to white (such as the example on page 64). Low-key is on the dark end of the value gray scale, from middle gray to black *(fig. A)*. High-key and low-key paintings can have low- or high-color saturation *(fig. B)*.

3. Using a pencil, make large shapes on the prepared paper. Draw lines reaching from one side of the paper to the opposite side, making shapes with straight and rounded edges. Create movement with the lines and vary the sizes of the shapes. You can also try drawing design and color ideas first in your sketchbook *(fig. C)*. Once you draw the composition on the paper, decide if you will approach making a high-key or low-key painting or both.

4. Flat brushes make clean edges so paint the largest shapes using a ½" (13 mm) flat brush. Paint colors of middle value and average color saturation. In a high-key painting, for instance, try adding white to the colors to make them lighter and less intense. Alternatively, increase the amount of water mixed with the colors. As you progress, work toward the extremes, toward the lightest and darkest areas as well as the more saturated colors. Keep in mind when using a low-key palette that the darkest colors should be applied last since it is difficult to paint over them or remove them.

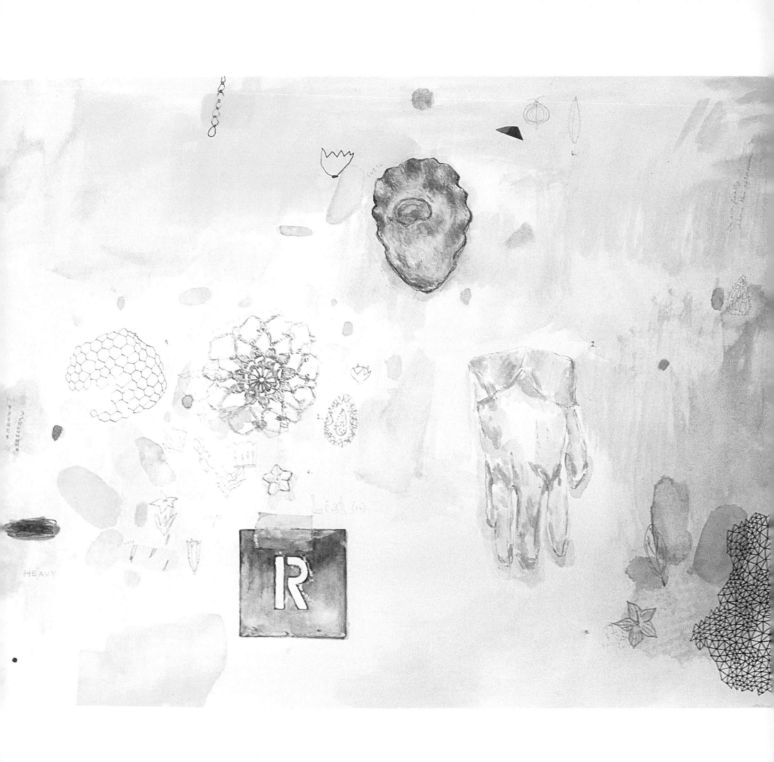

A White Painting:

USING THE WHITE OF THE PAPER AND LIGHT WASHES

MATERIALS

- HB or H pencils
- painter's tape
- flat brushes sizes 1/2", 3/4", 1" (13, 19, and 25 mm)
- round brushes sizes 0, 2, 4, 6, and 8
- watercolor in tubes or pans
- handmade watercolor
- piece of hot-press paper, 17" x 22" (43.2 x 55.9 cm)
- jars for water
- paper towel or fabric blotter
- palette

MAKE A PAINTING that evokes quietude using a high key color palette. Incorporate layering methods such as hatching and cross-hatching to give dimension in open spaces.

Process

1. Cut or tear the watercolor paper to size. Using a ruler, measure a 12" x 16" (30.5 x 40.6 cm) image area and draw the frame lines lightly on the paper with pencil. Use low-tack painter's tape to secure the outside edges around the image area. This makes a clean edge on the finished painting.

2. If you desire specific subject matter for this painting, although unnecessary, choose something of interest to you. Ideas include setting up a still life of white objects, working from a photograph, a bright landscape or scene, or experimenting with simple shapes. The project example includes organic and nonorganic objects with predominately light local values *(fig. A, page 68)*.

A

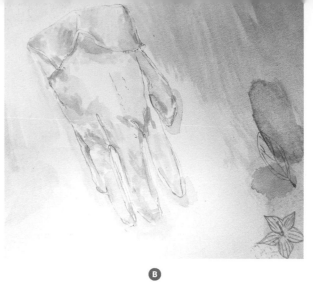

B

3. Draw your composition while keeping in mind that the graphite marks can be an integral part of the painting. With the largest flat brush, make washes in the background using light tints. To make a tint, a color plus white, either add white to a small amount of color or use the color with a large amount of water. Cover the entire ground with washes, changing colors and the direction of the brushstrokes as you go. Work with cool and warm color tints. Consider leaving the white of the paper visible in negative spaces.

4. Work objects or shapes into the foreground when the background is dry. Remember the whitest white you can obtain is the white of the paper. Tube, pan, and even handmade white paint won't be as light. So, if desired, block out the areas you want to maintain with masking fluid. Use a medium size round brush, such as a size 4 or 6, to make loose strokes showing the gesture of the forms *(fig. B)*.

5. Try using different painting techniques in the foreground spaces. Make hatch and crosshatch marks with short strokes using small size 0 and 2 brushes *(fig. C)*. Layer marks of tinted colors to show dimension in the objects or shapes. Or try applying medium to dark colors first and then glaze the white tints on top, as in the oyster shell *(fig. D)*. Applying whites and tints over the dark layers shows density and softens value edges. Allow the paint to dry between coats.

6. Finally, experiment with adding graphite drawing on top of the painting or incorporating watercolor crayons and pencils *(fig. E)*.

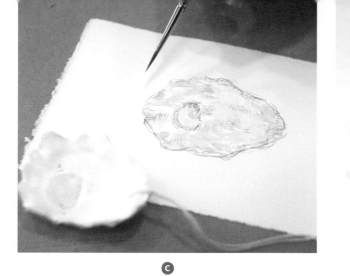

C

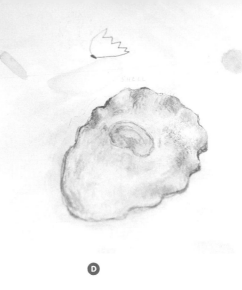

D

E

CONTRASTING MEDIA:

DRAWING AS A MAIN ELEMENT

FINE CONTOUR LINES, pattern, and lustrous detail focus the attention on drawing.

Process

1. Cut or tear the watercolor paper to size. Using a ruler, measure an 8 ½" x 11 ½" (21.6 x 29.2 cm) image area and draw the frame lines lightly on the paper with pencil. Use low-tack painter's tape to secure the outside edges around the image area. This makes a clean edge on the finished painting.

2. Gather inspiration from different sources. Consider imagery from art history, fabric patterns, and drawing from life to compose the piece. Decide on a layout by moving the loose items around. Use an H or HB pencil to draw the composition on the paper, beginning with the central or largest element. Continue with the background patterns and then the foreground details. Allow ample time to render the entire composition to the best of your ability. Vary the line quality, considering delicacy and line pressure to show weight, depth, or add emphasis (fig. A).

A

B

C

MATERIALS

- H or HB pencil
- wood or fiber board board, larger than paper size
- round brushes sizes 0, 2, 4, 6, and 8
- watercolor paints in tubes or pans
- piece of 140 lb (300 gsm) soft- or hot-press watercolor paper, 11" x 14" (27.9 x 35.6 cm)
- jars for water
- palette

3. First paint the background imagery, patterns, or other material. Use soft colors to create light or atmosphere *(fig. B)*. Intense colors will make an active or contrasting background while dark colors can give a sense of depth.

4. Paint the foreground areas you want to render in full color and detail. Use glazing and wet on dry painting with small brushes. Aim for accuracy and lustrous color and enjoy taking your time with the details *(fig. C)*.

5. Does the piece feel balanced with both painted and drawn areas? Do some of the contour lines need to be emphasized with more pencil pressure? Do you want to add light washes of color in the foreground? Continue asking yourself questions to reach your desired result.

LIGHT AND SHADOW:
USING VALUE TO ORGANIZE A PAINTING

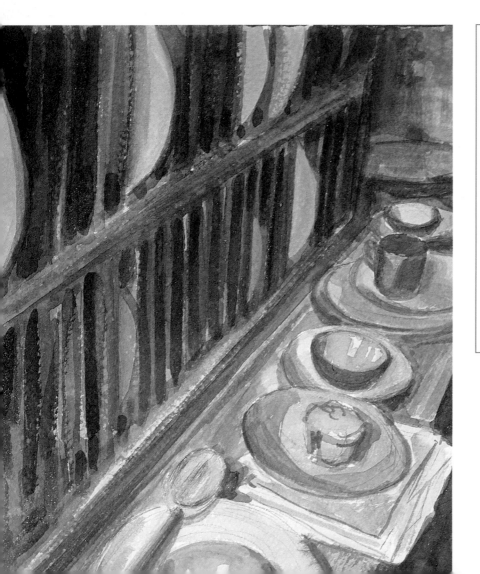

MATERIALS

- H or HB pencil
- magazine image for inspiration
- flat brushes sizes ½", ¾", 1" (13, 19, and 25 mm)
- round brushes sizes 2, 4, and 6
- watercolor in tubes or pans
- piece of rough-press paper cut to size
- jars for water
- paper towel or fabric blotter
- palette

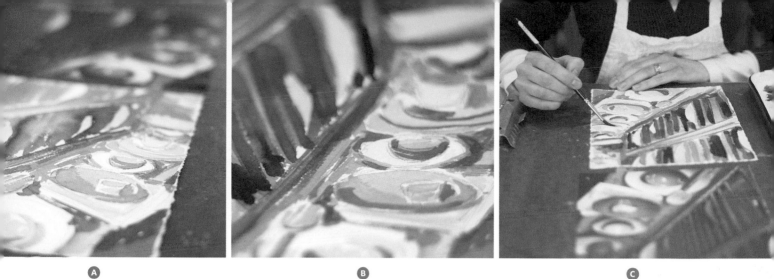

A

B

C

PAINTING A COMPLETE RANGE of values can be a challenge. We are easily allured by color before understanding the values inherent within the color. This project helps us think about and see value as a way to anchor a piece and give it strength.

Process

1. Select a magazine image from which to work. Choose one that has values from light to dark. Cut or tear the watercolor paper to a size that corresponds with the found image.

2. Sketch the composition in pencil, noting the placement of essential shapes. Draw the negative shapes and shadows as they are important in "holding up" the positive areas. For instance, in a predominately low-key image, the light values can lead the eye through the piece in a rhythmic way, creating depth. The placement of the dark values forms a pattern of light and shadow, organizing the composition.

3. Begin to paint the dark areas within the composition using a neutral tint. Retain the lightest areas by painting around them *(fig. A)*. When you suggest the dark areas, you will promptly see the value structure forming in the painting *(fig. B)*. Build the deepest values by glazing wet on dry.

4. Paint the large sections of middle and light values while still keeping the lightest whites. Continue to paint in the positive and negative shapes, decreasing the size of your brush to work into smaller sections. Finally add linear detail and subtle color *(fig. C)*.

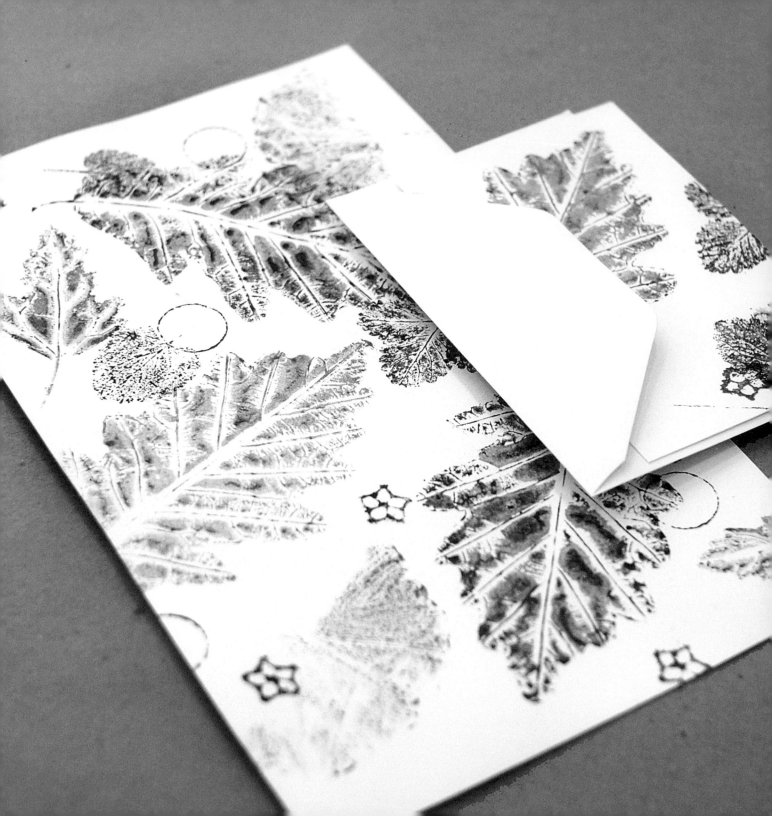

INSPIRED BY NATURE:

PRINTING WITH LEAVES

MATERIALS

- leaves
- scrap paper
- envelopes, if desired for practical application
- 140 lb (300 gsm) paper, 6.5" x 10.5" (16.5 x 26.7 cm)
- watercolor paints in pans
- round brush size 6
- jars for water
- paper towel or fabric blotter
- palette

A VARIETY OF FOUND NATURAL MATERIALS are used to make a beautiful pattern of fallen leaves. This project explores the concepts of repetition and overlapping shapes.

Process

1. Select a variety of fresh, dried, or pre-pressed leaves to use as printing material. Choose leaves of different sizes and shapes, with pronounced edges and lines.

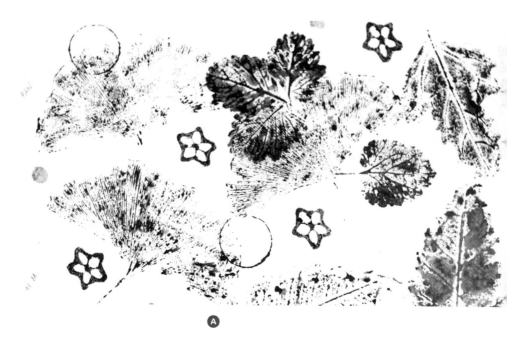

Ⓐ

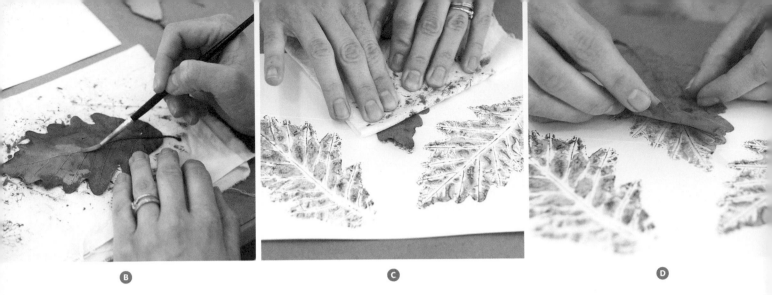

B

C

D

2. Using the scrap paper, test each leaf first to see which ones print best *(fig. A, page 75)*. To do the test, select the side of the leaf with the most relief, keeping in mind it may be the back. Lay the leaf on a paper towel or blotter and paint the entire side of the leaf. Saturate the brush so it has a higher ratio of paint than water *(fig. B)*. If the paint is too watery, it may not show the details of the veins. Some leaves are waxier than others, so they may resist the paint at first. Once a leaf is evenly covered, lift it carefully and place it painted side down onto the paper. With one finger holding it in place, use the other hand to place a clean blotter on top of the leaf *(fig. C)*. Now press the leaf to the paper and rub firmly. The blotter will help prevent the leaf from shifting. Once rubbed entirely, lift the blotter and leaf to see the print *(fig. D)*.

3. Select the best printing leaves to use on the watercolor paper. Begin with a light color such as yellow or yellow ochre and one of the large leaves. Paint and print the leaf following the method in step two. Paint and print the large leaves, several times, considering the negative space, or space between them.

4. Next choose a smaller leaf to print using a darker color, such as sienna or raw umber. Continue painting and printing, moving from large to small leaves and from light to dark colors. Allow the prints to layer and overlap, forming a pattern.

Make Something!

Cut the paper into fourths and use as announcement-sized flat cards, or divide in half for a folded card.

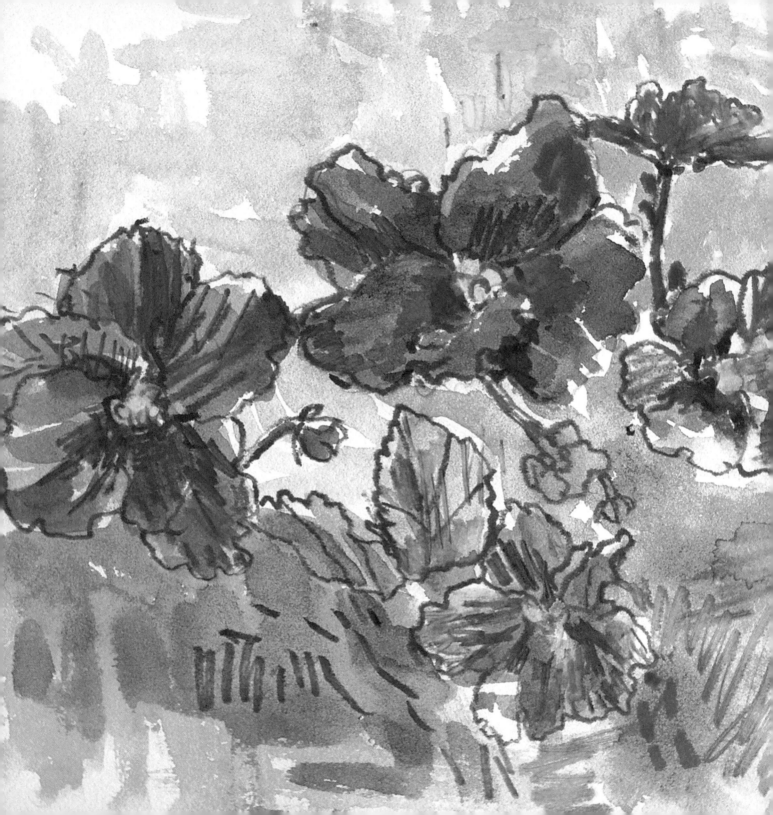

Exploring Media:

WATERCOLOR PENCILS AND WATER-SOLUBLE CRAYONS

MATERIALS

- water-soluble colored pencils
- water-soluble wax crayons
- scrap watercolor paper
- wood or fiber board, larger than paper size
- round brushes sizes 2, 4, 6, and 8
- watercolor paints in tubes or pans
- piece of 140 lb (300 gsm) soft- or cold-press watercolor paper, 6" x 6" (15.2 x 15.2 cm)
- jars for water
- palette

USING WATERCOLOR PENCILS and crayons with watercolor can be a fun way to fuse drawing and painting.

Process

1. Cut or tear the watercolor paper to size. If desired, make the paper larger than suggested and tape the edges to a board. Otherwise, the drawing and painting can extend to the edges as in the project example.

2. Watercolor pencils and crayons can be used for most any type of painting. They can be used in landscape, abstract, and large- and small-scale work. They are also fun to use for making cards. For this piece, decide on a direction to try. It may be interesting to work from life or have some subject matter in front of you *(fig. A)*. Wet the paper with fresh water and a large brush. Begin drawing

Ⓐ

the subject loosely with a neutral or dark watercolor pencil to show contrasting edges. The pencil should glide smoothly on the wet paper *(fig. B)*. Draw the entire composition and if desired, incorporate other pencil colors as well.

3. When the composition is drawn, use tube or pan watercolors and a medium size 4 or 6 brush to wash in the largest foreground shapes *(fig. C)*. Begin with the light colors and then move to darker colors. Add vivid colors to add contrast. While the paint is wet, draw lines with the watercolor pencils or crayons to show surface direction, to mass an area, or add texture *(fig. D)*.

4. Once the foreground has a few layers, begin working in the background. The colors and marks in the background will alter the way the foreground looks, so don't expect to finish the foreground completely yet. Consider using the brush as a drawing tool in the background to make large hatching or crosshatch strokes. Remember to reserve the white of the paper for the lightest areas. Choose a mid-value color and begin painting around the foreground shapes. The brush marks can go in multiple directions and do not need to follow the contours of the actual imagery. Work the entire background with a variety of colors. Use the pencils and crayons to add more drawing if desired.

5. Once the background is complete, there may be areas in the foreground imagery that need to be darker or parts where the color needs to pop with hits of vibrant color *(right)*.

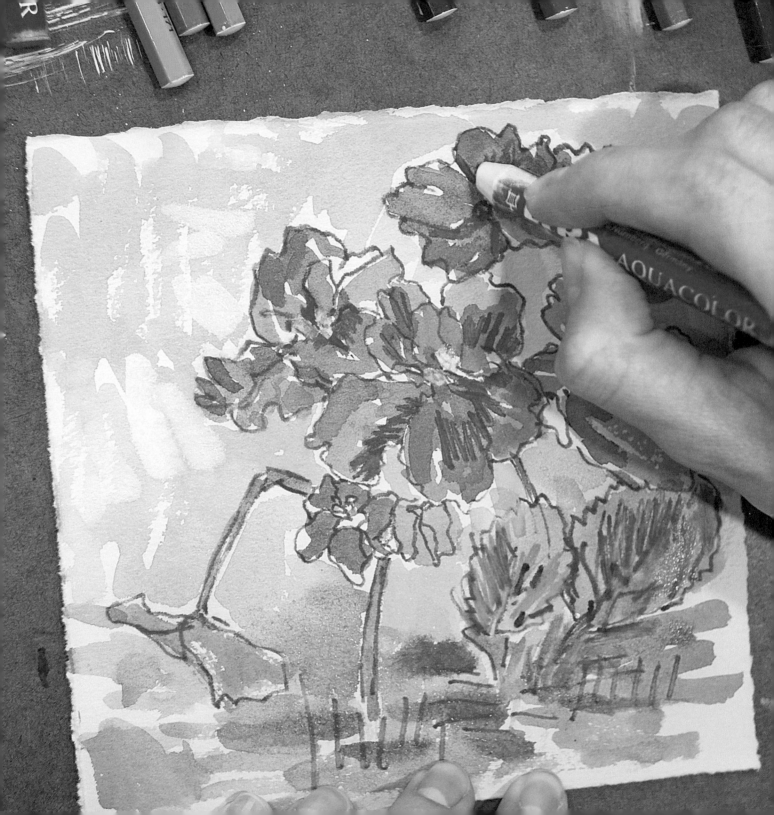

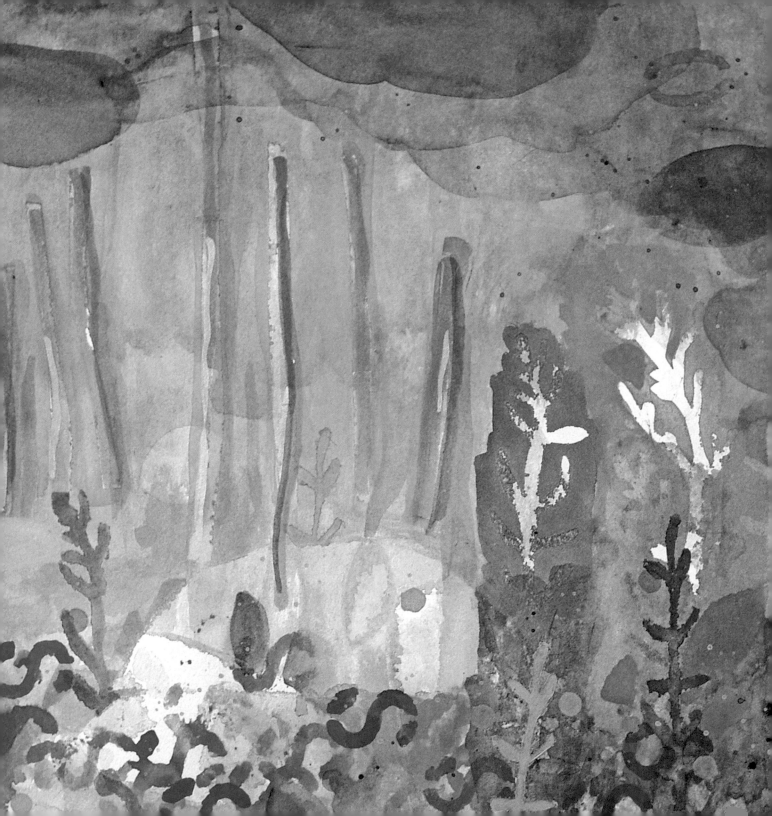

MASKING AND STENCIL PROJECT:

CREATING NEGATIVE SHAPES WITH TAPE AND STENCILS

MATERIALS

- low-tack painter's tape
- ready-made paper alphabet stencils
- contact paper
- scissors
- craft knife
- fine tip permanent marker
- wood or fiber board, larger than paper size
- round brushes sizes 4, 6, 8, and 10
- flat brush size 1" (25 mm)
- watercolor paints in tubes or pans
- piece of 140 lb (300 gsm) hot-press watercolor paper, 10" x 11" (25.4 x 27.9 cm)
- jars for water
- paper towel or fabric blotter
- palette

USE TAPE, READY-MADE STENCILS, and handmade contact-paper stencils to create a richly layered painting full of shape and color.

Process

1. Cut or tear the watercolor paper to size. Stretch and adhere the paper to a wooden or fiber board support as described on page 14.

2. Cut three to five geometric shapes out of the contact paper. The positive and negative parts of the stencil can be used. Remove the adhesive backing and space the stencils on the fresh watercolor paper. Make washes of color across the entire paper using a large round or flat brush, being sure to paint over the stencils *(fig. A)*.

3. Once the paint is dry to the touch, remove the stencils *(fig. B, page 84)*. To add more layers, apply the same stencils in new locations on the paper *(fig. C, page 84)*. Wash the paper again with another color *(fig. D, page 84)*.

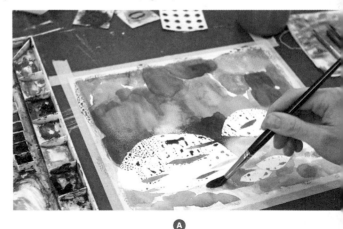

Ⓐ

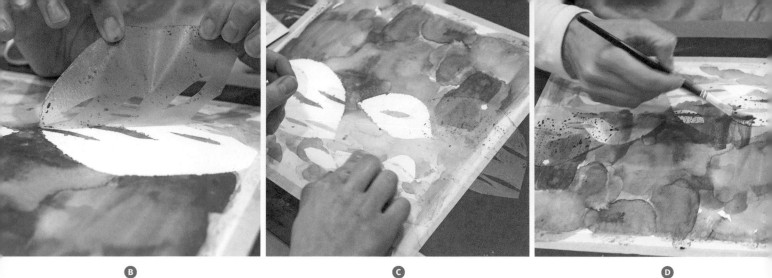

B C D

Considerations

Stencils made from contact paper can be reused within the painting. They will still mask an area, yet the paint may seep under the edges. The seeping might create irregular edges that can be visually interesting. See sample stencils shown at right.

4. Select letter stencils, like those used for sign painting, commonly found at hardware or office supply stores. Choose an area of the piece to repeat a pattern of letter shapes, perhaps near the bottom or top of the paper. Hold the stencil down securely. Use a small synthetic brush, such as a number 4, to dab bright color through the stencil *(fig. E)*. Then, lift the stencil and place it in a nearby spot. Continue painting with the stencil to make a repeating pattern.

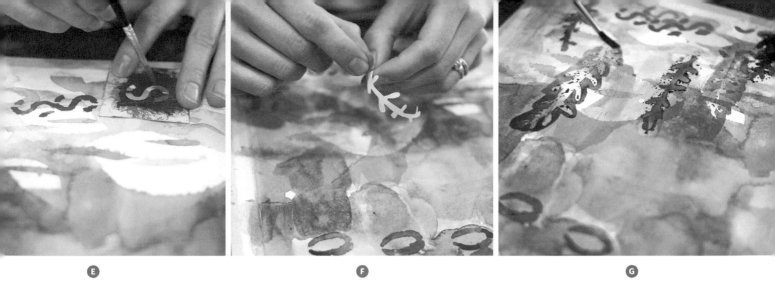

E F G

Considerations

Are there areas that need darker values? Are more intense or bright colors needed to unify the painting? Perhaps some simple brush-strokes can define the existing shapes. When you have decided it is complete, carefully re-move the tape from the edges of paper *(right)*.

5. With a fine tip permanent marker, draw a specific shape on the back of a piece of contact paper. Make three to five shapes in various sizes or forms and adhere them to the painting *(fig. F)*. This time select a dark color such as a deep blue, green, or black to add depth and contrast to the previous layers *(fig. G)*. Use a smaller brush to paint over and around the stencils. Once dry, remove the stencils.

6. Finish the painting by adding details and small shapes. Try tiny circle stencils, add more hand-cut stencils, or paint over strips of masking tape to incorporate lines. Masking tape makes a good covering tool, resists bleeding, and offers a smooth edge.

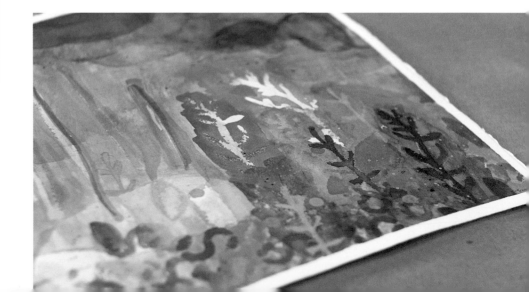

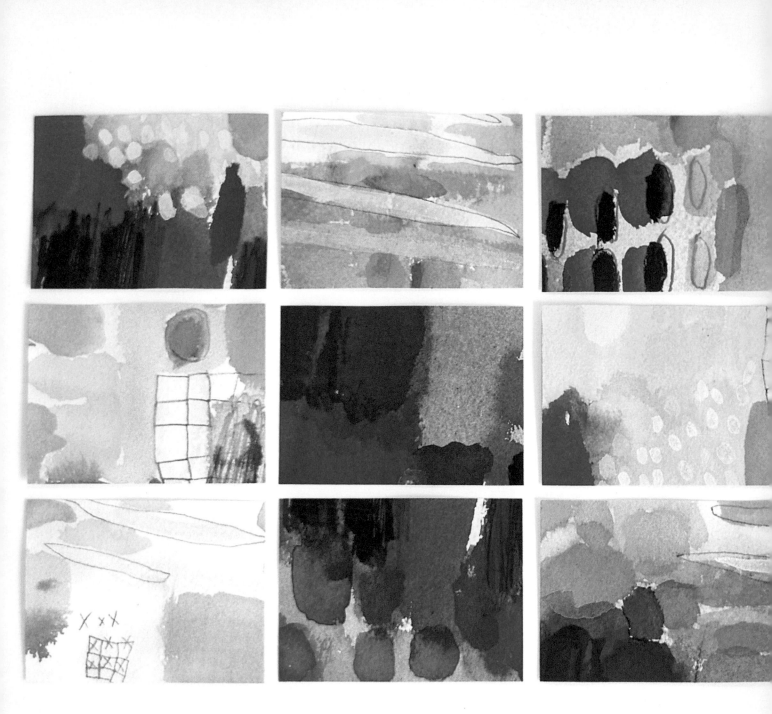

Deconstruct and Reconstruct:

CUT AND REASSEMBLE A LARGE PAINTING

MATERIALS

- low-tack painter's tape
- craft knife
- straight-edge ruler
- colored pencils (optional)
- watercolor crayons (optional)
- watercolor pencils (optional)
- wood or fiber board, larger than paper size
- round brushes sizes 4, 6, 8, 10, 12, and 14
- watercolor paints in tubes or pans
- piece of 140 lb (300 gsm) cold press or rough watercolor paper, 8" x 11" (20.3 x 27.9 cm) or larger
- jars for water
- paper towel or fabric blotter
- palette

THIS TWO-PART PAINTING PROCESS embraces playfulness and can also promote confidence. Explore using vibrant color and experiment cutting the painting into small pieces. Arrange the work into a different sequence and make new formations.

Process

1. Cut or tear the watercolor paper to size. Stretch and adhere the paper to a wooden or fiber board support as described on page 14. Let the paper dry before painting.

2. Moisten and mix your favorite colors on the palette. Use large round brushes such as 10, 12, and 14 to make large free-form marks across the paper *(fig. A, page 88)*. Paint broad washes or try making loop shapes, zigzag lines, and large areas of color. Cover the entire paper with different shapes and colors. If desired, dab the paper to remove excess paint between layers *(fig. B, page 88)*. Try not to overanalyze what you are painting. Have fun and explore.

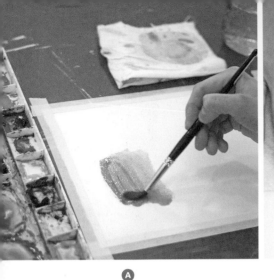

A

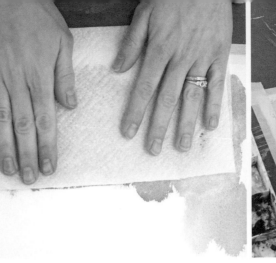

B

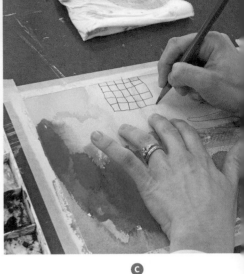

C

3. With smaller brushes and the drawing materials, make distinct shapes and lines in a variety of sizes within the piece. Draw small squares, ovals, or other shapes with pencil *(fig. C)*. Try painting overlapping circles or dots in contrasting colors *(fig. D)*. Make all the areas of the painting interesting; consider the colors, values, shapes, and lines within each space.

4. When you are finished painting, carefully remove the tape from the edges of the paper. Use a craft knife to cut off the white edges left by the tape. Then using either a craft knife and a ruler or a paper cutter, cut the whole painting into 2 ½" x 3 ½" (6.3 x 8.9 cm) pieces *(fig. E)*. Dissecting the original piece will alleviate the tendency to consider the work precious.

5. Contemplate arranging the paintings in a grid pattern. Look at the individual pieces in different directions and move them around, trying several arrangements *(fig. F)*. Notice the space between the edges and whether the shapes, colors, and lines visually connect from piece to piece. Rather than one vibrant painting, you now have many smaller ones that when viewed together gain new vitality *(fig. G)*.

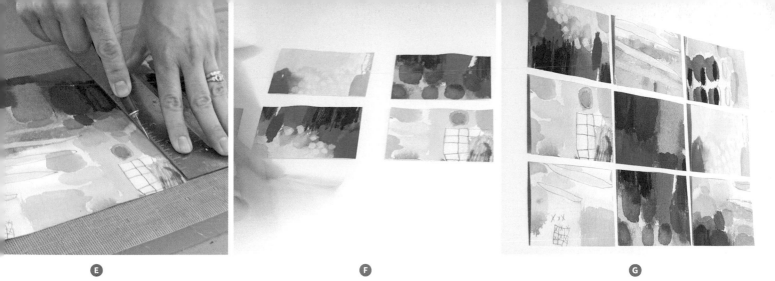

E

F

G

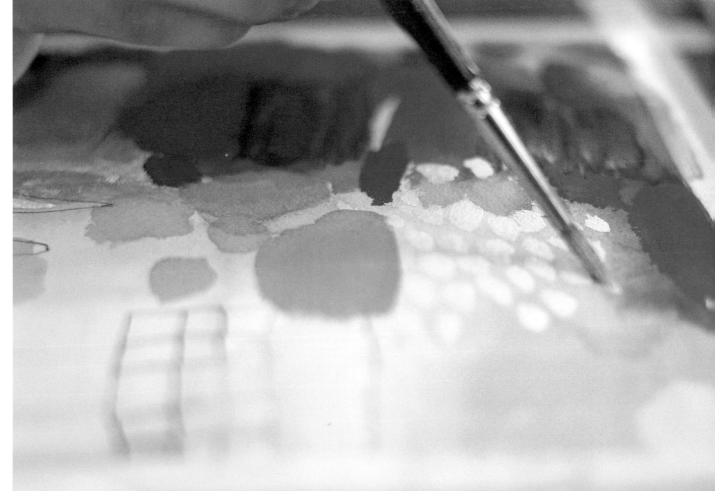

D

ART CARD PROJECT:
MAKING TINY ART

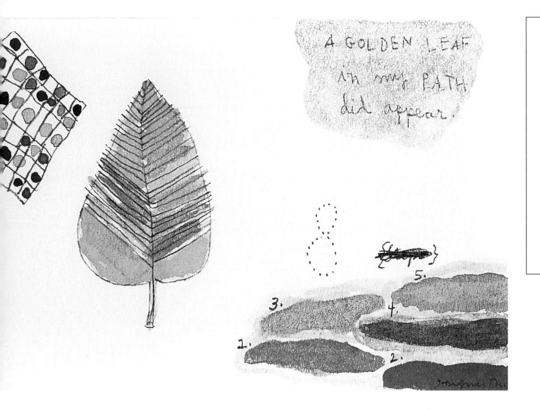

A GOLDEN LEAF
in my PATH
did appear.

MATERIALS

- round brushes sizes 0, 2, and 4
- watercolor paints in tubes or pans
- one or more pieces of watercolor paper, 2 ½" x 3 ½" (6.4 x 8.9 cm)
- jars for water
- paper towel or fabric blotter
- palette

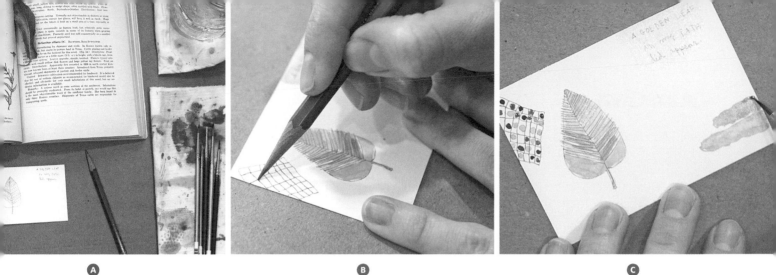

A B C

OPEN TO VARIOUS approaches from representational to abstract, this project embraces making tiny art. The artist trading card (or ATC) is collectable among artists and a fun way to use scrap paper from other projects.

Process

1. Use paper remnants from other projects for the art card or try working into one of the pieces from "Project 17." Depending on the amount of drawing you plan to do, determine the best surface paper accordingly. The smoother papers allow for more detail. Cut or tear the paper remnants to 2 ½" x 3 ½" (6.3 x 8.9 cm) pieces and keep them on hand to make tiny paintings as your schedule allows.

2. One possible way to approach the art card is to begin with a single thought or idea. The idea can be imagined or a visible object in front of you from which to draw. Begin with an image and draw it on the paper *(fig. A)*. Then, add some watercolor to the drawing.

3. What story begins to emerge as you are drawing? Write a few words, a poem, or a simple description to illustrate the thoughts that come to mind. The handwriting is a visual part of the entire piece. You could also try using small letter stamps or stencils to incorporate text.

4. Add more color, shapes, or patterns to the painting *(fig. B)*. Consider the relationship of the parts to one another. What elements should be larger than others? How much space is between the objects, shapes, writing, and patterns? Think about how the composition evolves on this small scale and envision how you could translate it to a larger scale *(fig. C)*.

5. If new ideas arise while working on this piece, consider jotting them down in a sketchbook or beginning a new art card. Since these works are small, they allow for fast flowing ideas.

COLLAGE:

WORKING WITH PAPER EPHEMERA IN A PAINTING

MATERIALS

- paper ephemera
- acid-free glue
- scissors
- craft knife
- round brushes of various sizes
- watercolor paints in pans or tubes
- piece of 140 lb (300 gsm) cold-press watercolor paper, 11" x 15" (27.9 x 38.1 cm)
- jars for water
- paper towel or fabric blotter
- palette

USING FOUND PAPER CAN bring forth new ideas and ways of applying materials.

1. Gather together paper ephemera or bits of found paper. Consider using antique book pages with text or photos, dress-making patterns, recipe cards, maps, notebook paper, old food can labels, music sheets, photocopies, etc. There are many possibilities, so select items that inspire you. The pieces can be used as a background for the painting or as elements added to the painting *(fig. A)*.

2. Select and move a large piece of found paper around on the watercolor paper to begin thinking about the composition. If both sides of the found paper are interesting, try folding it in some way to reveal the front and back *(fig. B)*. Set another large piece of ephemera near the first. Cut and arrange it in different ways. Notice how when one thing is next to another it can change the entire thought process and how you perceive the elements. Use an acid-free glue to adhere the pieces to the watercolor paper.

3. Working with found materials can encourage you to think inventively and constructively. What images, writing, shapes, or stories could tie these disparate bits together? This project, like others, is about problem solving rather than only learning a certain painting technique. While thinking of concepts to relate in the piece, remem-

A

B

C

ber the basic building blocks of line, shape, color, texture, form, value, and space. Try drawing lines or overlapping shapes that grow out from the found papers. Or try painting shapes or images directly on the found material in contrasting colors to add variety.

4. Create emphasis by adding small areas of focus either by cutting and attaching more found paper elements or drawing on the painting *(fig. C)*. The bee on the project example was drawn by observing a photocopied image, yet the copy could have also been glued to the piece. The way you arrange the elements or compose muted or bright colors within the space can help create a painting that is balanced in a stable or asymmetrical way. Sometimes turning the painting around while working on it will help you determine the best orientation.

DARK SUBSTRATES:

INCORPORATING OPAQUE AND IRIDESCENT WATERCOLORS

MATERIALS

- round brushes sizes 0, 2, 4, 6, 8, and 10
- handmade watercolor (Refer to the Basics chapter for recipe and instructions.)
- iridescent watercolors
- piece of black paper, 12" x 14" (30.5 x 35.6 cm)
- jars for water
- paper towel or fabric blotter
- palette

COMBINE PATTERN, depicted imagery, and opaque washes using watercolor on darker papers. Add subtle emphasis by incorporating iridescent paints.

Process

1. When black paper isn't readily available, prime the paper with a matte black acrylic paint *(fig. A, page 96)*. Prepare a scrap piece of paper as well to test colors and ideas *(figs. B and C, pages 96 and 97)*.

2. Once the paper is prepared, think about how to approach the piece. Do you want it to be image-based, full of pattern, or incorporate writing or stencils? Choose the subject or follow a few suggestions. Try selecting a swatch of fabric that has a large repeating pattern. Use the pattern as inspiration and draw the design on the paper in pencil. The graphite lines will reflect on the dark surface as you draw. Use a small brush to highlight some lines with a light color of paint, such as yellow ochre. Then fill other parts of the pattern with color to emphasize the shapes. Notice the black paper absorbs

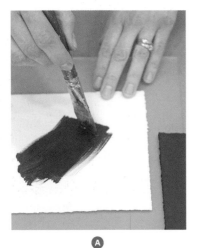

paint quickly, so depending on the density of color, you may desire multiple coats of paint. Yet, because handmade watercolor can have a higher pigment-to-medium ratio than tube or pan watercolor, you can build opaque layers on top of previous colors.

3. If you want to make part of the pattern visually recede, use a large brush charged with black paint and quickly wash over the colors. Dab excess paint with a towel. The black wash conceals, acting as an "eraser" and imbeds part of the image into the paper. Allow parts of the pattern to remain visible. This under painting can become the background of the piece.

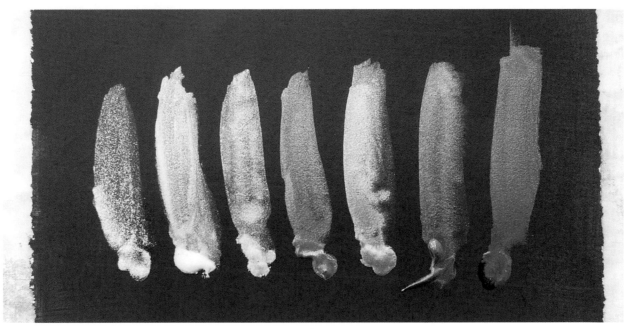

C　　　　　　　　　　　　D　　　　　　　　　　　　E

Considerations

Consider using hand-made watercolor on the dark paper. Mixing your own paint allows you to control the pigment density and make heavier-bodied paint. As you mix, make some tinted colors or colors mixed with white pigment. Commercial watercolor will also work in this project; it may just be harder to build light colors. In addition, transparent layers appear darker on the black paper than on white paper.

4. Contrast the dark with white or a tint by using a small brush, such as a size 2 or 0, to paint a large image or pattern, *(fig. D)*. Continue adding imagery such as large botanical images, seeds, lines, and small scenes around them. Combine items of different sizes floating near one another. Incorporate color washes or try dry brushing large areas of the piece. Notice the edges of the brushstrokes. Make some strokes have clear or hard edges and some with soft or diffused edges. While layering the imagery, remember you can dab the paint to remove excess or use the black "eraser" color as necessary *(fig. E)*.

5. Finally, use the iridescent watercolor to highlight specific elements that you want to emphasize or draw attention to in the painting. Try making iridescent color washes on the black paper and add detail to the color layers. When light reflects on the surface, the iridescent paint will shimmer and contrast the matte or opaque handmade watercolor.

LANDSCAPE PAINTING:

USING A LIMITED PALETTE AND A VIEWFINDER

MATERIALS

- viewfinder or heavy paper to make a viewfinder
- Conté crayons or pencil
- low-tack painter's tape
- watercolor tape
- ruler or square
- craft knife
- wood or fiber board, larger than paper size
- fold-up chair
- field easel, if available
- flat brushes sizes ½", ¾", 1" (13, 19, and 25 mm)
- round brushes sizes 2, 4, and 6
- watercolor paint
- piece of cold-press paper, 10" x 15" (25.4 x 38.1 cm)
- jar with a lid for water
- paper towel or fabric blotter
- small towel

CAPTURING ALL THE MINUTE DETAILS of a landscape can be mind-boggling. Instead, select a few details that you feel are most important to capture. Practice using a viewfinder to focus on a selected area and "see" what is before you.

Process

1. Cut or tear the watercolor paper to size. Stretch and adhere the paper to a wooden or fiber board support as described on page 14. Use a ruler to measure a 6" x 10" (15.2 x 25.4 cm) image area, and draw the frame lines lightly on the paper with pencil. Use low-tack painter's tape to tape the outside edges around the image area.

A B C

2. A viewfinder helps isolate and select a composition. To make a viewfinder, cut two L-shape pieces from a piece of heavy paper, chipboard, or mat board using a square and craft knife. Overlap the shapes in the desired format, rectangle or square, and secure them together with removable tape *(fig. A)*.

3. Prepare your supplies for travel. Wrap brushes in a canvas brush carrier or simply wrap a rubber band around the brush handles and roll them up in a small towel. Carry water in a lidded jar and use a large plastic jug if more water is needed. The limited palette of a simple watercolor set is suitable for this project. A field easel and fold-up chair are convenient, but if they aren't available, just sit with the drawing board resting on your lap *(fig. B)*.

4. Set up a comfortable workspace outdoors. Look through the viewfinder with one eye shut to find an interesting composition. Using the viewfinder is similar to looking through a camera lens and helps you select information while blocking out distractions. Once you have decided on a location, use the Conté crayons or pencil to sketch your composition lightly. The Conté crayons are water-soluble, so if you don't want the color to blend with the watercolor, use pencil or watercolor pencil instead.

5. Begin painting with a large flat brush and broad strokes. Choose a neutral color predominant in the landscape for the first washes, such as a sepia or yellow ochre in the example *(fig. C)*. Remember to reserve the white of the paper for the lightest areas. To remove paint that is too dark, simply wet the area and dab with a towel to lift the paint and lighten the value. Look constantly at the scene and then quickly back to your paper as you are working, focusing mostly on what is before you. It is important to work fast since the light shifts quickly, changing the shadows and colors. Continue to use the viewfinder during the initial stages of drawing and painting until the information is in place on your paper.

6. As you paint, see the values in the landscape. Where are the largest dark areas, and where does the light hit? Also think about the temperature of colors. For instance, does the light reflecting from certain foreground elements make them appear warm in color? Does the background recede into a cool blue? Neutral tones may be more difficult to determine. Try to see the warm and cool within the tones to relay a sense of space in your painting.

Captured Images:

WORKING FROM A PHOTOGRAPH

MATERIALS

- photograph
- H pencil
- painter's tape
- ruler or square
- flat brushes sizes
 ½", ¾", 1" (13, 19,
 25 mm)
- round brushes sizes
 2, 4, and 6
- watercolor in tubes
 or pans
- piece of cold-press
 paper, 11" x 9"
 (27.9 x 22.9 cm)
- jars for water
- paper towel or
 fabric blotter
- palette

THE EYE OF THE CAMERA sees in a nonobjective way, capturing light and the subject differently than the way we perceive our surroundings. Paint from a photograph you have taken and find inspiration in the way a camera sees.

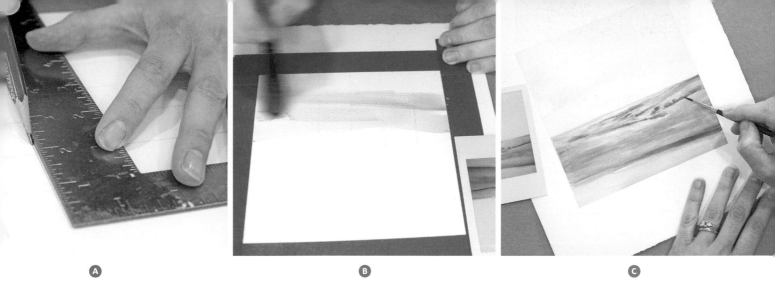

A B C

Process

1. Cut or tear the watercolor paper to size. The format of your photograph determines the paper dimensions and image area. If you work from a Polaroid, measure a 6" x 6 ¼" (15.2 x 15.8 cm) image area with a ruler and draw the frame lines lightly on the watercolor paper. Use low-tack painter's tape to tape the outside edges around the image area. This makes a clean edge on the finished painting.

2. For precise image placement, make a grid for the photograph and one for the watercolor paper. Draw a grid on tracing paper using a square or ruler and place it over the photograph. Then lightly draw a corresponding grid in a 1:2 ratio (or larger depending on paper size) on the watercolor paper using an H pencil *(fig. A)*. For instance, a ½" (1.3 cm) square on the photo is equal to 1" (2.5 cm) on the paper. Making and using a grid is optional.

3. Sketch the composition lightly in pencil. Draw the main shapes and divisions of light and dark.

4. Use a large flat brush and broad strokes to paint the main section of the piece *(fig. B)*. Follow the direction of your drawn shapes. As you paint,

focus on seeing value, light, and shape rather than objects or subject matter. Instead of thinking of what is depicted in the photograph, think in terms of "there is a light horizontal shape that reaches across the paper here and a dark shape that angles this way" and so on. Furthermore, trees may not look like trees in the photo but perhaps like a diminishing band of shapes that are a middle value and green *(fig. C)*. If you can try to think about elements rather than the actual things, the final piece may depict the desired illusion.

FINDING INSPIRATION IN A POEM

"winter comes in whispers. frost etchings decorate windowpanes. the crows gather on gnarled branches, their wings creating inky paintings in the cold air."

—*Shari Altman*

MATERIALS

- poem or prose
- round brushes sizes 0, 2, 4, 6, and 8
- watercolor paints in tubes or pans
- piece of 140 lb (300 gsm) hot-press watercolor paper, white or neutral in color, 5" x 7" (12.7 x 17.8 cm) or larger
- jars for water
- paper towel or fabric blotter
- palette

THE WRITTEN WORD can inspire the visual art making process. Using a poem as inspiration, this project explores how to get from the text to the image. It also discusses how the painting can evoke an emotional response through the telling of a story.

Process

1. Select an interesting poem that brings images or pictures to mind. The project piece is inspired by the prose written by writer and friend, Shari Altman.

A B C

2. With the poem in front of you, make a brainstorm list of ideas in a sketchbook (*fig. A*). Write down the words or phrases in the poem that stand out by noting the word and the image it inspires. Select at least five words or phrases to think about using in the art piece and draw small thumbnail sketches of your ideas. The idea of the poem that is most prominent or interesting to you can be the focus. If necessary, select source material such as photographs or objects. Having concrete items to draw from may help in the process.

3. Cut or tear the watercolor paper to 5" x 7" (12.7 x 17.8 cm) or larger. With your ideas and sketch on hand, begin working on the painting. First draw or paint the largest objects or patterns (*fig. B*). Then add in other imagery, keeping in mind they can be smaller or a lighter color than the main idea.

Sometimes, when working on a subjective project like this, the artist encounters a problem. The painting doesn't always progress the way we imagine, no matter how we plan or prepare. Rather than abandon the piece, work with the frustration. Serendipitously, the process of working through a problem may reveal surprises and new meanings (*fig. C*).

4. As the painting proceeds, consider ways to use pattern, texture, or nonobjective shapes to represent the ideas of the poem. For instance, the project example has a floating pattern of white oval shapes near the bottom to convey how the "frost etchings decorate windowpanes." In addition, there may be areas to draw in a representational or realistic way.

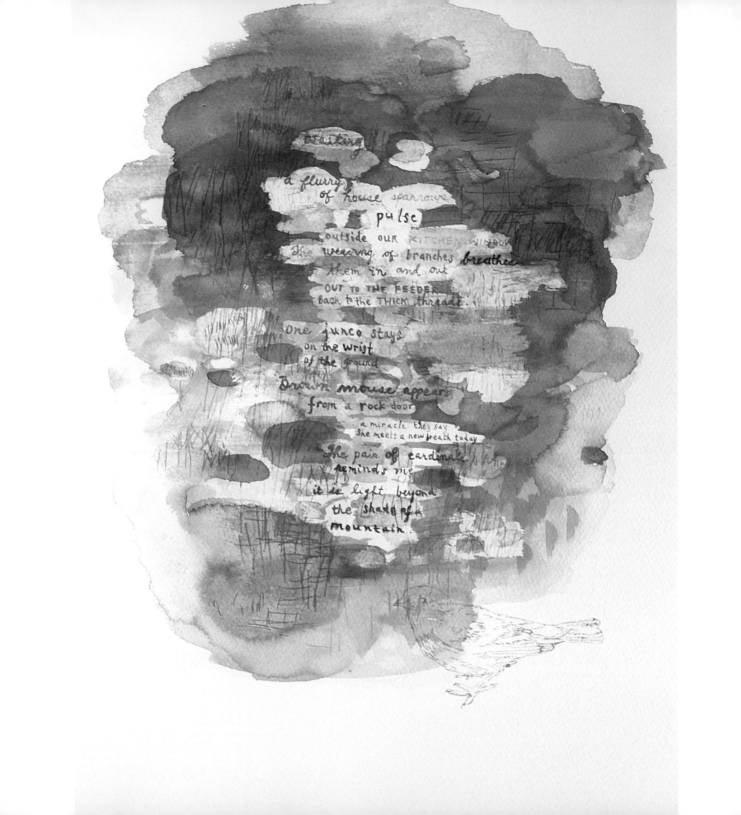

LINES AND LETTERS:

WRITING WITH WATERCOLOR

MATERIALS

- colorless art masking fluid
- rubber cement eraser
- old brush for use with masking fluid
- round brushes sizes 0, 2, 4, 6, 8, and 10
- script brush sizes 0 or 2
- watercolor paints in pans or tubes
- piece of 140 lb (300 gsm) cold-press watercolor paper, 11" x 15" (27.9 x 38.1 cm)
- jars for water
- paper towel or fabric blotter
- palette

Tip

Use only an old or inexpensive brush with masking fluid. Do not use a good brush because the latex in the fluid can ruin the bristles of a brush. Wash the brush promptly and thoroughly after use.

EXPLORE WRITING with watercolor, additive and subtractive painting processes, and paper etching, all within a broadside format.

Process

1. A broadside is traditionally a ballad printed on one side of a sheet of paper. Today printmakers and artists use this format for poetry and creative writing. Select a poem or other piece you or a friend have written to feature in the painting.

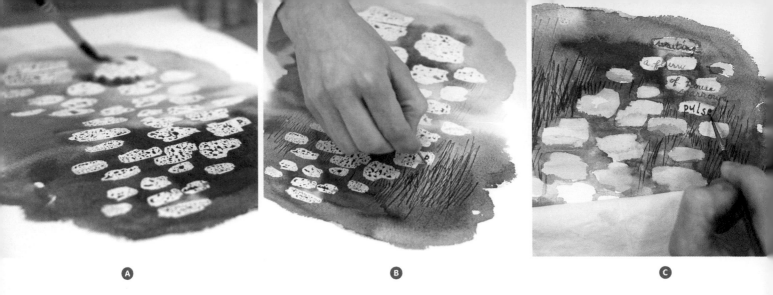

A B C

Considerations

Try adding texture to the paper by scratching into wet paint with either a nail or stick pin. The watercolor will appear darker in the etched areas *(fig. B)*.

2. With an old brush dipped in the masking fluid, make organic shapes or lines across the watercolor paper from top to bottom. While the masking fluid is drying, mix the color palette indicative of the imagery in the writing. When the masking fluid is dry, use a large brush, size 10 or 8, to make color washes. Paint over and around the masked areas *(fig. A)*. When the paint is dry, either add more color washes or remove the masking fluid with a rubber cement eraser.

3. Use a small round brush, size 0 or 2, or a small script brush to write the text *(fig. C)*. Consider writing in different formats and combining them within the piece. Try writing in cursive, in all capital or all lowercase script, calligraphy, or even use stencils. Change colors, if desired, as you work. If you want the finished piece to be precise and organized, measure guide lines on the paper. Otherwise, allow the writing to flow naturally.

4. When all the writing is complete, use the masking fluid to cover certain areas you want to keep; let dry. Then use the same color palette to paint more shapes, balancing the colors throughout the piece. Remove the masking fluid with the rubber cement eraser when the paint is dry. At this point, there may be words to stress by darkening their color or emphasizing the color around the word. Alternatively, try disguising words by wetting the area and removing paint with a blotter. This subtractive method will visually embed the writing into the paper *(fig. D)*.

flurry
of house wrens
pulse
outside our kitchen window
the weaving of branches breathes
them in and out
OUT TO THE FEEDER
BACK to the THICK thread

one junco stays
on the wrist
of the ground

Brown mouse appears
from a rock door

a miracle they say
she meets a new breath today

The pair of cardinals
reminds me

it is light beyond
the shade of a
mountain

5. Finally, consider adding an image or recognizable pattern that expresses the written concepts. Another option is to draw or paint a border around the edge of the paper to finish the piece.

SEEDS

PRINT AND PAINT:

ADDING WATERCOLOR TO A MONOTYPE

MATERIALS

- piece of windshield-grade glass, larger than paper size
- etching or relief ink, oil or water-based
- brayer
- painter's tape
- round brushes sizes 0, 2, 4, 6, 8, and 10
- large, flat brush
- watercolor in tubes or pans
- printmaking paper, such as Rives heavyweight 175 gsm, 10" x 11" (25.4 x 27.9 cm)
- jars for water
- paper towel or fabric blotter
- palette

THIS PROJECT EXPLORES using deliberate and unexpected modes of working. Explore the element of surprise through printmaking and painting. Create a multi-layered piece and experiment with a simple monotype method called direct-trace drawing.

Process

1. Using light colors and large to medium sized brushes, make washes, shapes, and marks on the paper *(fig. A, page 110)*. These nonobjective marks will be the painting background and will be visible in the final layers.

2. The next step involves a monotype method called direct-trace drawing. Prepare a work surface for printing by arranging the glass, ink, brayer, and paper. Use painter's tape to frame an image area on the glass that is smaller than the paper size. Within the tape frame, place a pea-size amount of ink on the glass *(fig. B, page 110)*. Roll the ink with the brayer in a thin even layer *(fig. C, page 110)*. The ink should make a slight tacky sound when rolling but should not look gummy; less ink is better. If you feel you have too much ink, scrape some away with a palette knife and then smooth the remaining ink with the brayer. Remove the tape when the ink is thin and evenly spread.

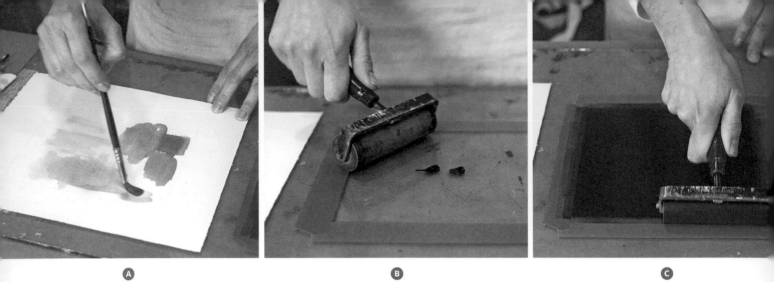

A B C

Tip

If you don't have the suggested paper on hand, try using a light-weight watercolor paper, such as 90 lb (190 gsm) or less. The paper needs to be smooth, either hot or soft press. A heavier weight or rough tex-tured paper may not accept the printing process.

3. With the painted side down, carefully set the paper onto the inked glass, being sure not to press it into the ink with your hand; handle the paper only around the edges. Use small pieces of tape to hold the paper in place and prevent movement. Use a pencil or other instru-ment to draw your design on the backside of the paper *(fig. D)* or draw your image on the back of the paper before setting over the ink, and simply trace the lines when in place. The stress of the pencil will press the ink to the paper, making a print *(fig. E)*. While drawing, try not to rest your hand on the paper, making an unintended impression. When finished drawing, gently lift the paper, turning it over to see the print *(fig. F)*.

4. If you used water-based ink, wait at least an hour to let the ink set. Then add painted details with bright colors and small brushes. Try emphasizing some existing color shapes by glazing colors on top *(fig. G)*. I used oil-based ink, and while I allowed no wait time, I used thin layers of paint, dabbed excess paint with a blotter, and worked carefully around the printed areas. If you notice the watercolor pulling the ink, simply let the ink dry.

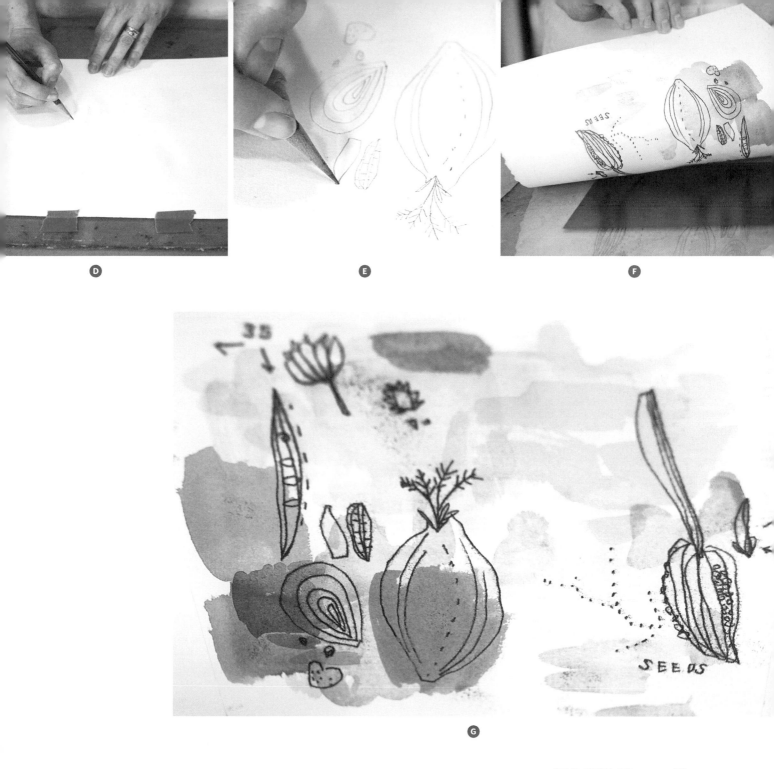

Found Materials:

WORKING ON AN ANTIQUE POSTCARD

MATERIALS

- antique postcard
- HB pencils
- tracing paper
- round brushes sizes 0, 2, and 4
- watercolor in tubes or pans
- handmade watercolor (Refer to the Basics chapter for recipe and instructions.)
- jars for water
- paper towel or fabric blotter
- palette

INTEGRATING YOUR ARTWORK with existing imagery and text on alternative surfaces can provide new ways of looking at and understanding your work. Antique postcards offer a small-scale format as well as two sides to explore.

Process

1. Vintage postcards can usually be found in antique shops and flea markets. Look at the font styles, postage stamps, images, slogans, and handwriting on the cards as you choose. Select one or two made of heavy paper stock. You can paint on the front, back, or both sides of the card.

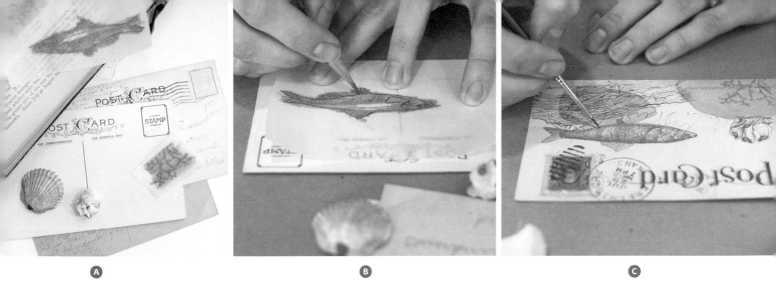

A

B

C

Tip

Aged paper can be fragile. Use thin paint applications and allow paint to dry between layers to keep the paper from becoming too wet.

Considerations

Do you want your painting to imitate or stand out against the imagery on the card? In other words, do you want your additions to be seamlessly part of the original material or dynamically different?

2. Draw your ideas, images, shapes, and patterns on tracing paper *(fig. A)*. Cut each element from the paper so you can move the drawings about independently. Tracing paper is a useful tool to help you arrange your composition and visualize how your art will integrate with the found elements before painting them in place. Once you have decided what to include, either draw directly onto the card or turn the tracing paper image into graphite transfer paper. To make the transfer paper, rub the back of the tracing paper with the side of your pencil, covering the image area completely. Then with the image side facing up, place the transfer paper over the desired location on the card. Trace over your initial lines, transferring your drawing to the postcard *(fig. B)*.

3. When all the information is drawn in place, decide how to paint the piece. Tube and pan watercolors are suitable for line work and transparent layering. If you want to build opacity in certain areas of the painting, try using handmade watercolor. Paint the transparent and background parts before the detailed and opaque areas *(fig. C)*.

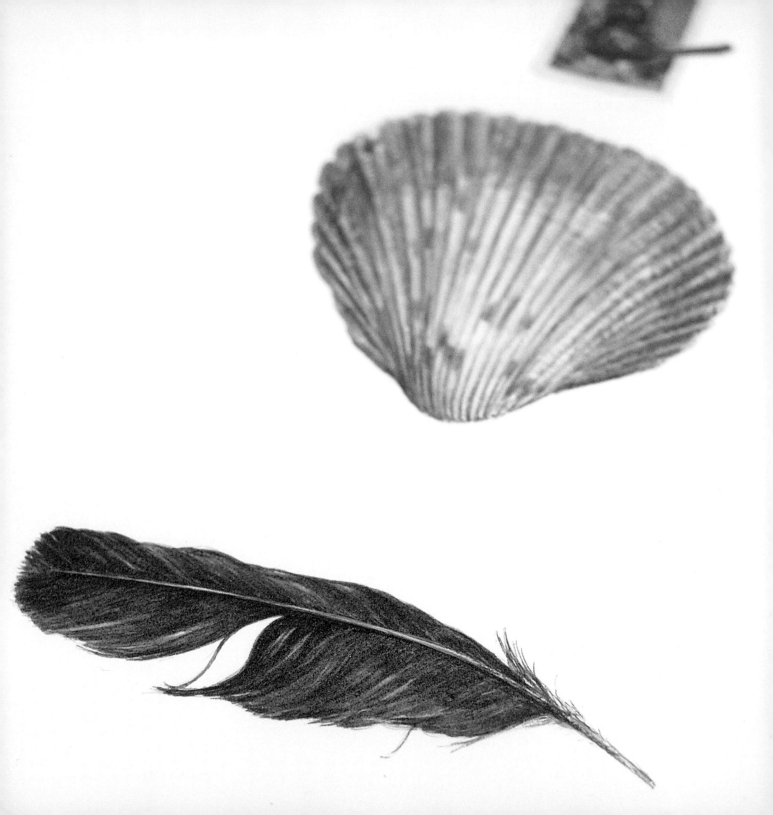

STILL LIFE:
PAINTING AN ARRANGEMENT

MATERIALS

- selected objects
- white board for arranging items, 10" x 12" (25.4 x 30.5 cm)
- H or HB pencil
- gum arabic
- round brushes sizes 00, 0, 2, 4, and 6
- watercolor pan paint and/or handmade watercolor
- sheet of 140 lb (300 gsm) hot-press paper, 10" x 12" (25.4 x 30.5 cm)
- water jars
- blotter
- palette

PAINTING FROM ARRANGED OBJECTS encourages the exploration of placement on a white ground. Draw from life and practice ways of representing various surfaces and textures.

Process

1. Choose three to five objects of interest for the subject matter of the painting. Consider items that share similarities or offer differences in size, color, texture, surface qualities, and so on. The arrangement can contain objects of contrasting textures, like a leaf, a feather, and something metal. Or they can tell a story through the similarities and share a common shape or color.

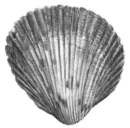

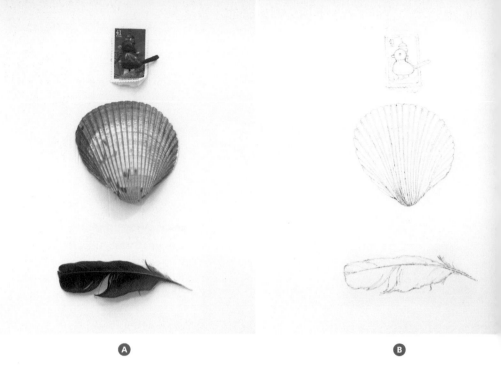

A B

2. Move the objects around on a white board before committing to a composition. Since the board is the same size as the paper, it will help to visualize the space between and around the objects. Flip the pieces around, look at them near and far from one another, consider the undersides, and try them in an overlapping configuration. Decide how they form the most successful and interesting arrangement *(fig. A)*.

3. Use the pencil to lightly draw the arrangement on the water-color paper, beginning with the largest object. It is helpful to render enough information to show the forms, textures, color, shapes, and details before painting. Keep in mind that some pencil lines may be visible and even desirable in the finished piece. Proceed to draw all the objects in place on the paper *(fig. B)*.

4. Begin painting the largest object with a large brush, or size 6. Make watery washes with light values and colors, reserving the white of the paper for the lightest areas or highlights. Consider working wet in wet in some areas. For instance, the initial layers of the shell use wet in wet painting with large brushstrokes *(fig. C)*.

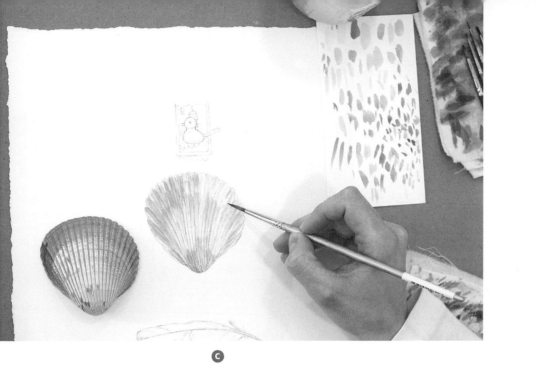
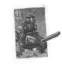

C

D

Tip

In dark objects like the black feather, luminosity can be enhanced by adding small drops of liquid gum arabic to the paint colors while mixing on the palette. The gum arabic creates a slight sheen, makes colors more translucent, and will help the dark tones to appear less flat on the paper (*See the feather detail, page 114*).

5. Add the medium values by layering wet paint onto dry with smaller brushes and shorter brushstrokes. Continue to build tonal layers to show the form of the objects. Before painting the darkest areas, repeat these painting steps within the smaller objects until all parts are painted in light to medium values.

6. After each object has been painted, look at the painting as a whole and work in the darkest values moving from one object to another. Using the 00, or smallest brush, add pertinent details such as wisps on a feather, tiny perforation marks on the edge of a stamp, or curved lines on the shell *(fig. D)*. Then, if necessary, reinforce highlights using heavy-bodied white watercolor.

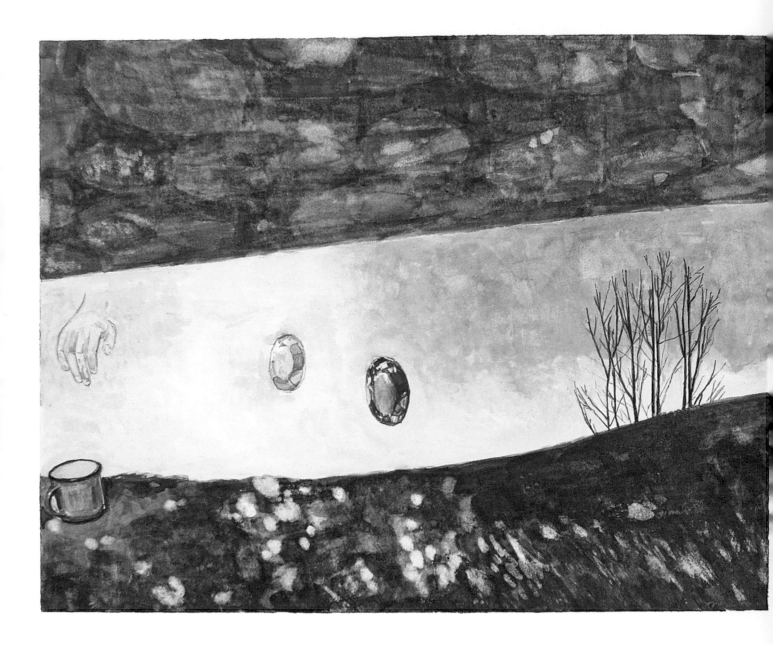

Magazine Collage:

INSPIRING COLOR AND COMPOSITION FOR A PAINTING

MATERIALS

- old magazines
- piece of mat board or other stiff paper board
- craft knife and scissors
- low-tack painter's or artist's tape
- double-sided adhesive tabs or glue
- round brushes sizes 4, 6, 8, and 10
- watercolor paints in tubes or pans
- sheet of hot-press 140 lb (300 gsm) paper, 11" x 13" (27.9 x 33 cm)
- jars for water
- paper towel or fabric blotter
- palette

Tip

While looking for source material, turn the magazine upside down. This will help you see shape and texture more readily instead of selecting pieces based simply on what the image depicts. Viewing from a different perspective will help you notice different elements.

CREATE A PAINTING inspired by a collage of interesting shapes, textures, and colors gleaned from magazine images.

Process

1. Gather magazines to cut out pictures or sections that are interesting to you. Look for images with textural areas and photos with appealing color patterns and different values. Tear or cut out at least a dozen different pages or sections, keeping in mind that they can be parts of a page instead of the whole page *(fig. A, page 120)*. Select pieces intuitively, or if you prefer order in your search, choose pieces with certain colors or narrative in mind. For instance, select images that balance light and dark values, have heavy and delicate lines, or incorporate a tactile appearance.

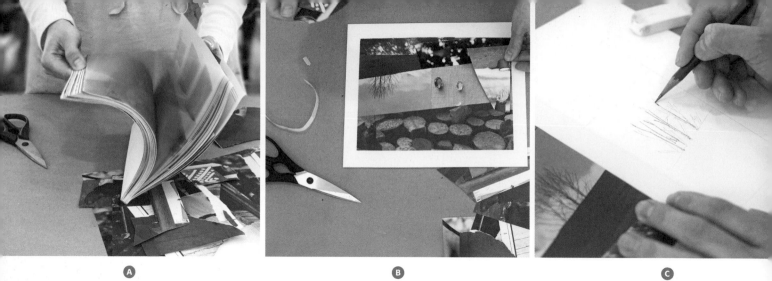

A

B

C

2. After selecting the magazine images, move them around on the mat board *(fig. B)*. Try overlapping some of the pieces and cutting other parts out. Arrange the pieces and remember to look at the entire composition as a whole. Use glue or double-sided tape to adhere the papers to the board.

3. Cut or tear the watercolor paper to 11″ x 13″ (27.9 x 33 cm). Using a pencil, lightly draw the 7″ x 9″ (17.8 x 22.9 cm) image frame on the paper, which will leave a white frame around the painting when finished. Tape the edges using low-tack tape. Press the tape firmly to the paper by running your fingernail across the surface or use the side of a bone folder. Securing it to the paper in this way will help prevent paint from bleeding under the edges.

4. Sketch the composition on the paper while looking at the magazine collage. Draw the main sections and key elements, including prominent lines, colors, and value changes *(fig. C)*.

5. Choose one of the large sections to begin painting the main values and shapes. Use a large brush, such as a number 8, to make free-form washes, keeping the marks loose *(fig. D)*. Press with the side of the bristles to make broad shapes and use the brush tip to mark the shape edges. Continue to paint loosely within each section, moving from color to color, until the entire painting has some descriptive information. The painting may be a lively color or tonal sketch.

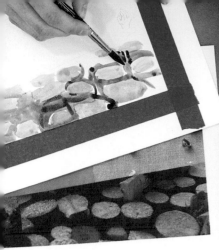

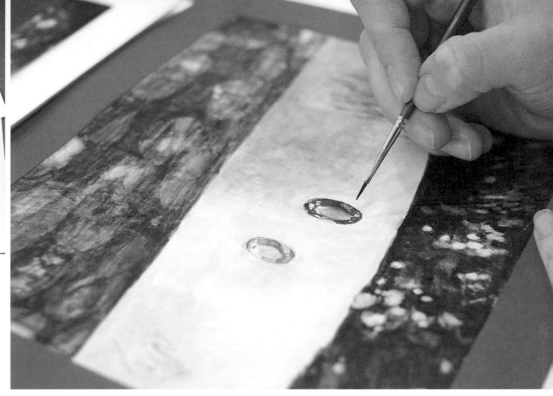

D

E

6. From this point, the painting can take on different directions based on the way you want to paint. How do you want to paint certain areas of the collage? Try using a wet on wet technique to create a sense of atmosphere. For more descriptive and detailed areas, painting wet on dry is effective. Build up the painting in sections and remember to look at the piece as an entirety.

7. To complete the painting, decide which areas need further detail or realism *(fig. E)*. In contrast, are there areas that are successful as they are? Balance the painting with a variety of textures, detail, and range of values.

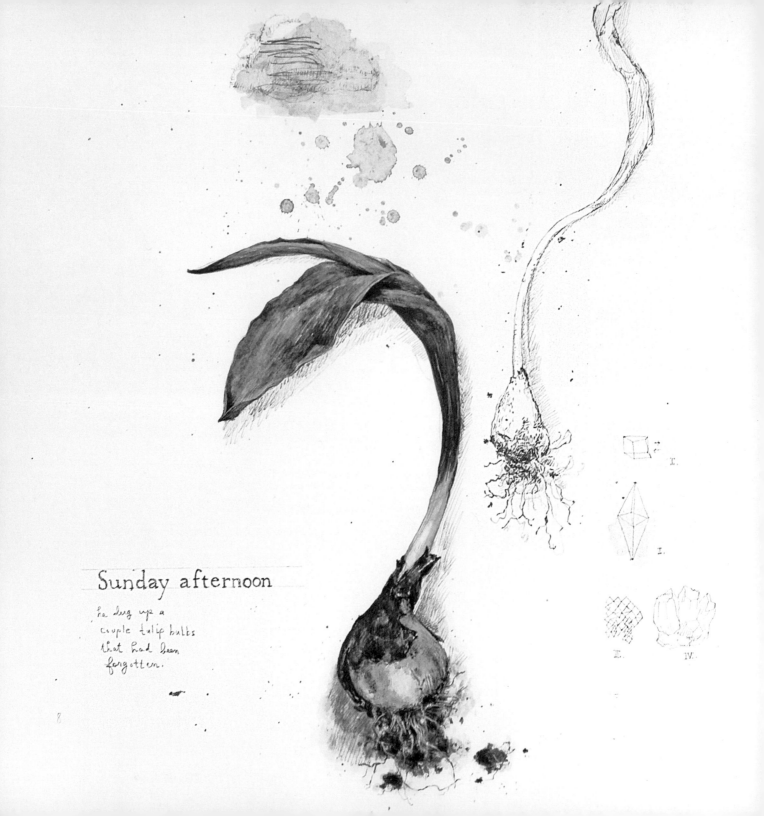

Sunday afternoon

He dug up a
couple tulip bulbs
that had been
forgotten.

8

BOTANICAL PAINTING:

DRAWING FROM NATURE

MATERIALS

- flora from which to draw
- HB or H pencils
- round brushes sizes 0, 2, 4, 6, and 8
- watercolor in tubes or pans
- piece of hot-press paper 10 ½" x 17" (26.7 x 43.2 cm)
- jars for water
- paper towel or fabric blotter
- palette

INSPIRED BY BOTANICAL ART, observe the natural world as a starting point in which to add areas of invented imagery.

Process

1. Gather or purchase a flower stem, bulb, or a wild plant from the yard to use as the subject. Whether in a vase or set on the table next to you, make sure to have the object close for careful study *(fig. A, page 124)*. Begin drawing on the watercolor paper with an H or HB pencil understanding the entire gesture and form. Draw the largest shapes and lines, saving the tiny details for later. To show broad surfaces and shadows, use hatching (parallel lines) and cross-hatching (lines at an angle to one another) marks *(fig. B, page 124)*. Pay attention to proximity of the lines and change their direction as forms change to show volume. Make lines closer together and over-lap lines to show dark areas and give a sense of depth. The more you look at and study the flora, the more you will actually see. When the forms are perceptible and accurate, incorporate characteristic details with fine lines *(fig. C, page 124)*.

A B C

Tip

To create a dry brush effect, wipe the paint-saturated brush on a blotter before brushing on the paper. The paint should not pool or look wet. Rather, it will create a textural stroke with slightly evident bristle marks *(fig. F)*.

2. Draw new information, real and invented, around the main subject. Recalling historical botanical studies and bookplate engravings, consider adding a ribbon of text, geometric forms, seed studies, or notations on the flora's environment *(fig. D)*.

3. When you begin painting, test color mixtures in your sketchbook, on a scrap of paper, or along the painting edge to help achieve naturalistic color *(fig. E)*. With the predominant color, paint the form of the largest shape. While the paint is wet, incorporate the value changes and other colors within it. Work wet into wet to give a sense of form without creating harsh edges.

4. When the paint dries, build layers of color using small brushes and repetitive dabs of paint. Use diluted washes of color on the hatch and cross-hatched areas so the drawn lines will be visible through the paint. Layering paint atop the drawing will add depth.

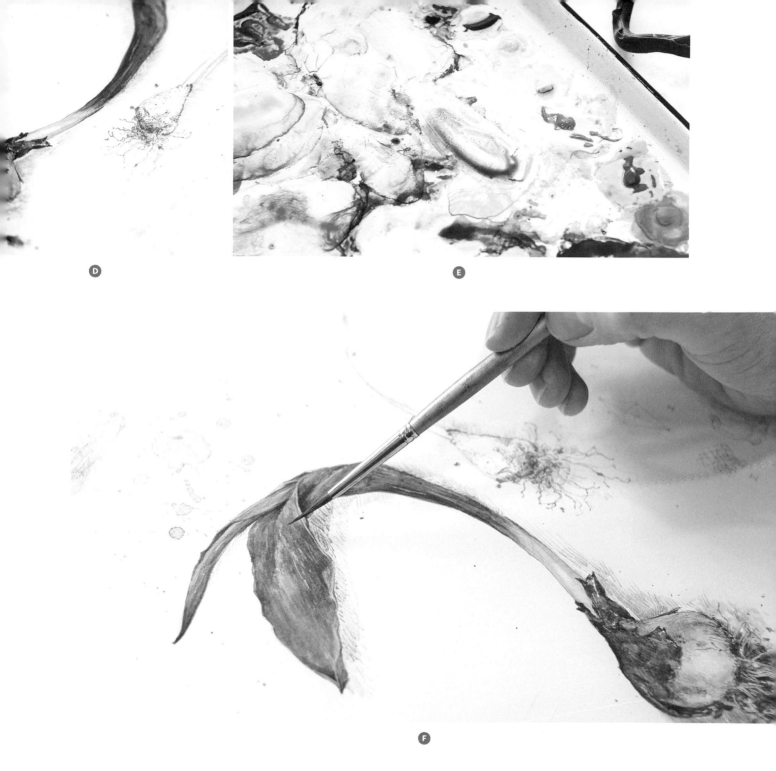

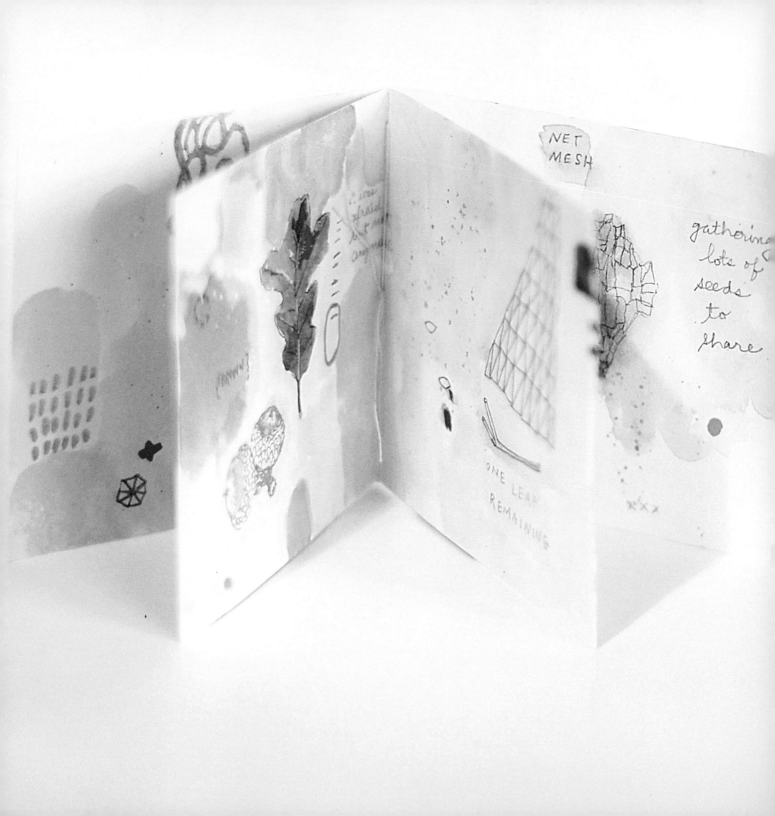

NET
MESH

gathering
lots of
seeds
to
share

ONE LEAF
REMAINING

SPECIAL PROJECT:
AN ARTIST'S BOOK

MATERIALS

- straight-edge ruler
- bone folder
- needle and thread
- pencil and colored pencils
- round brushes sizes 00, 0, 2, 4, and 6
- watercolor paints in tubes or pans, or handmade watercolor
- two pieces of 140 lb (300 gsm) hot-press paper, 3" x 6" (7.6 x 15.2 cm)
- jars for water
- paper towel or fabric blotter
- palette

Considerations

Approach this project as a mini journal. Consider using a story or narrative to link written thoughts with abstract and pictorial imagery. Let the source material be familiar, something found in your nearby surroundings or inspired by events from the day.

THIS PROJECT EXPLORES the idea of hand-held art. Use mixed media and a range of styles to make an original artist's book.

Process

1. Cut or tear two pieces of paper 3" x 6" (7.6 x 15.2 cm) or use strips of paper remaining from other projects.

2. Begin two pages with watercolor washes for the initial layers in an array of colors. Try making large, full oval shapes, rows of dots, small dashes, circles, and other organic forms with watercolor (*fig. A, page 128*). Incorporate handwritten text describing your thoughts and ideas.

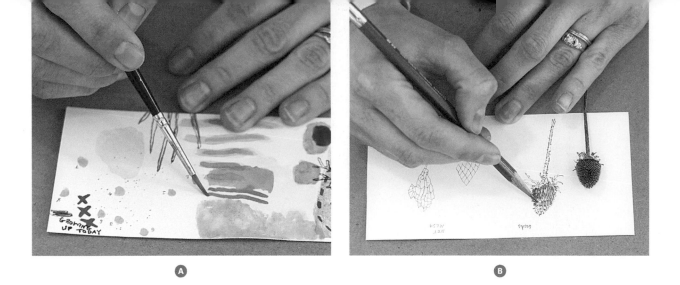

A **B**

Tip

Fill the pages with colorful imagery and text using pencil, colored pencil, and watercolor. Build both sides of the paper with thoughts and interesting elements from nearby surroundings *(See page 129, bottom)*.

3. Once those pages are dry, begin working on the reverse sides by drawing and writing in pencil. Try drawing items from nature, like an acorn, leaf, or dried flower stem. Draw abstract shapes or patterns and write next to the images *(fig. B)*.

4. When you have worked on each side, continue to work intuitively on all sides, moving fluidly as you go. Work with various brushes and move between brush, pencil, and colored pencil. Turn the paper around to look at your progress and make marks in new directions. Consider repetition, pattern, mark making, and narrative as ways to unify each page. Contrast large and small shapes and fully developed sections versus outlined areas. Keep in mind that the paper will be folded in half, so make sure each half of the paper is interesting.

5. To bind the pages together into a book, score a centerline crease on the papers using the straight-edge of a ruler and a bone folder. Scoring helps the paper fold easily. Stack the two scored sheets on top of one another and then use a pin to pierce three equally spaced and centered holes along the crease. With needle and thread, bind the pages using a saddle stitch *(fig. C)*. Alternatively, use a stapler to attach the pages.

c

Chapter Three:

GALLERY

THE ARTISTS SELECTED for the *Water Paper Paint* Gallery collectively capture the inimitable nature of watercolor. Each, through insight and talent, conveys his or her ideas with beauty, tenacity, mystery, and ingenuity. Some of the artists I knew prior to writing this book and others were discovered in the process. Each was chosen because I respect and admire his or her concept and aesthetic. These artists incorporate new media, collaborate with other artists, consider their paintings on a grand scale, and even develop new printmaking techniques to use with watercolor. The imagery, whether figurative or nonobjective, is sometimes familiar and yet unexpected. Watercolor itself is literally and metaphorically a transparent medium. As the viewer, we are at once aware of the paint's beauty but also transported by the artists' handling and overall arrangement. When you notice the tactility of the materials and then find yourself in the mind of the artist, beyond the tools themselves, these, to me, are signs that you are in presence of the finest kinds of paintings.

David Wilson, in his gestural, free-form representations of nature, is concerned with the notion of capturing and preserving fleeting moments. Floating small elements within a page, such as butterflies or a diminutive landscape, seem to be an act of preserving the passing of things. Where Wilson's work is about capturing the essence of something, Andy Farkas seems intent on discovery. Farkas considers himself to be a storyteller and his work to be about the process of finding and telling life's stories. He uses watery sweeps of color, written notations, and woodblock printing processes to weave together his ideas.

Many of Geninne Zlatkis's well-known pieces include bird imagery, painted in profile, with delineated wings and feathers, and mingled with flora all about. Yet to me, it's her journals that bear witness to her artistry. The richly layered pages embed life experience in every mark and word with depictions of the natural world at the heart. While Zlatkis's work is illustrative and full of pattern, Margie Kuhn paints objects, manmade and from nature, in detailed likeness, in a way that fools the eye. In her paintings, she removes items from context to examine the objects on their own and in relation to other elements and environments. Leaves, postage stamps, postcards, old photographs, clippings, and even bits of tape become transformed through her brush and are glimpses into a world which seems much more vast.

Anna Hepler and Christine Kesler pursue art making in different media, including three-dimensions and on a broad scale. Hepler builds sculptural forms from wire and from pieces of sheet plastic. She inflates the plastic forms and then watches them slowly deflate over time. She draws from those forms, whether wire or plastic, in their various states of transformation. Her drawn work shows an understanding of light, shadow, and perceived space, as informed by her sculptures. Christine Kesler takes her paintings and considers them within a larger scale. She uses a regenerative process of working into her previous paintings and drawings in order to destroy and rebuild them into something new. She arranges and installs the pieces all over the walls, allows them to unfold in a corner, or touch the floor. These installations form associations and ultimately blur boundaries of a once chronological process.

Selected Works

A few of the chosen artists collaborate with other artists. Carrie Walker gathers the discarded drawings of unspecified artists; some from the nineteenth century. She paints creatures into the found and desolate scenes, bringing life to pieces of art that were otherwise overlooked. The collaborative duo of Gracia Haby, (a collage artist) and Louise Jennison, (a watercolorist), known as Gracia & Louise, create works of art, artists' books, and zines. Lightly painted watercolors of jewels surround depicted images saturated with color, as if unearthed from history. Together they relay narratives of new and invented worlds. All of the artists delve into their imagination in one way or another, including Kyle Field, who through his imagery and color, reveals the inner workings of his mind. It is here, through his explorations, where we meet the unexpected and perhaps the unknown. His meandering lines feel at once automatic and lyrical and seem to marry the act of drawing with painting into one symbiotic process.

David Wilson
Moth Markings, (detail), watercolor on paper, 5 ¼" x 8" (13.3 x 20.3 cm).

Andy Farkas
Refresh, watercolor woodcut, 7" x 13" (17.8 x 33 cm).

"Each color in the print is a separate carved block and each is registered and printed using watercolor pigments and rice paste rather than oil-based inks."

River Study 5, graphite and watercolor, 6" x 6" (15.2 x 15.2 cm).

River Study 6, graphite and watercolor, 7" x 11" (17.8 x 27.2 cm).

Carrie Walker
(Top) To While Away the Time, watercolor and pencil on found drawing, 6 ½" x 9 ³⁄₈" (16.5 x 23.8 cm), 2008.

(Opposite) No Dominance Exists in the Coterie, watercolor on found painting, 3 ½" x 5" (8.9 x 12.7 cm), 2008.

"For this series, I have been collecting old landscape drawings and watercolor paintings from various sources such as eBay and thrift stores. I then carefully draw or paint animals into the landscape. The animals I insert are out of context and out of scale with their environment, resulting in a fantastical narrative, a story half-told. I consider the work to be collaborative, albeit one-sided. This series was initially conceived after buying a sketchbook full of landscape drawings for twenty-five cents in a thrift store in Chilliwack, British Columbia."

Margie Kuhn
(Top) American Sublime (detail), watercolor and gouache
on paper, 23" x 30" (58.4 x 76.2 cm).

(Opposite) Course of the Empire: Comanche,
watercolor on paper, 30" x 22" (76.2 x 55.9 cm).

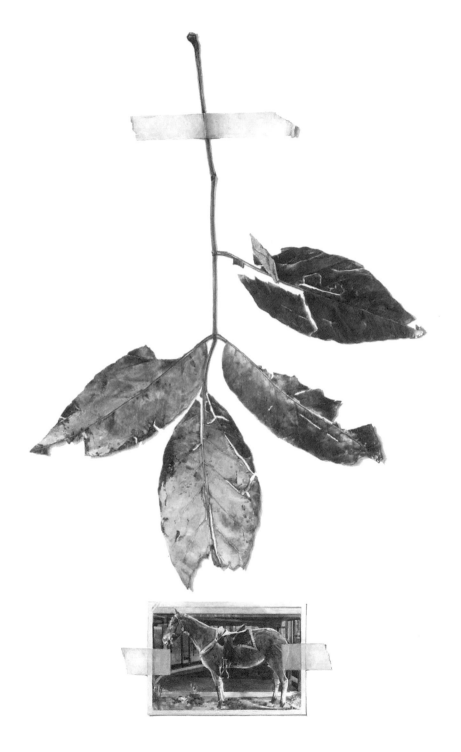

Geninne D. Zlatkis

(Top) September Pages, watercolor and acrylic ink on the pages of the artist's personal journal.

(Opposite) Three Little Birds, watercolor and acrylic ink on Fabriano paper.

Christine Kesler

(Opposite) I Got Lost, gouache, acrylic, watercolor, ink, and graphite on paper, 21" x 30" (53.3 x 76.2 cm), 2009.

(Right, top) The Construction of the World, acrylic, watercolor, and gouache on paper, 6" x 9" (15.2 x 22.9 cm), 2008.

(Right, bottom) Consonant, Installation detail shot. Mixed media on paper, panel, and canvas; site-specific installation, dimensions variable, 2009.

Anna Hepler
(Opposite)
Small Cyprus Drawing, 009.

(Right, top)
Small Cyprus Drawing, 021.

(Right, bottom)
Small Cyprus Drawing, 023.

*"Small watercolor and gouache
studies on paper, loosely
describing wire sculptural models
from my studio, from 2007."*

Gracia Haby and Louise Jennison
(Top and opposite right) Detail from the artists' book, *This Evening, However, I am Thinking of Things Past*; Twelve-page concertina, four-color lithographic offset print and color pencil on Fabriano bright white 300 gsm paper; *Title page*, watercolor and pencil on Fabriano bright white 640 gsm paper. housed in a 11″ x 9 ⁵⁄₈″ x 1″ (28 cm x 24.5 cm x 2.5 cm) balsa wood case with binding cloth bound by Louise Jennison; printed by Redwood Prints, edition of twelve, 2009.

(Left) Podlike Vessels, Abandoned But with Recent Modifications; detail from the artists' book *And We Stood Alone in the Silent Night*; A full-color digital print A5, perfect bound artists' book; 50 pages in length; 8 ¼″ x 5 ¾″ (21 x 14.7 cm); printed by Documents on Call, edition of fifty, 2008.

Kyle Field

(Top) Super Bloc, ink and watercolor on paper, 28″ x 36″ (71.1 x 91.4 cm), 2008.

(Opposite) Hood's Memory (Memory of a Hood), ink and watercolor on paper, 8 ½″ x 11″. (21.6 x 27.9 cm), 2008.

Heather Smith Jones

(Top) In the Sweet By and By, graphite and handmade watercolor on paper, image size 3³⁄₄″ x 5″ (9.5 x 12.7 cm), paper size 10″ x 11″. (25.4 x 27.9 cm).

(Opposite) 7.11, graphite, handmade watercolor, acrylic, decals on paper, image size 6³⁄₄″ x 9″ (17.1 x 22.9 cm), paper size 11″ x 15″ (27.9 x 38.1 cm).

CONTRIBUTING ARTISTS

Images courtesy of the individual artists, unless otherwise noted.

Altman, Shari
Contributed a short piece of writing as inspiration for Project 23: Painted Verse: *Finding Inspiration in a Poem.*

Farkas, Andy
www.fablewood.com
andy@fablewood.com

Field, Kyle
www.kyledraws.com
littlewings333@hotmail.com
Mr. Field's images courtesy of Kyle Field and Taylor de Cordoba, Los Angeles.

Haby, Gracia
www.gracialouise.com

Hepler, Anna
www.annahepler.com

Jennison, Louise
www.gracialouise.com

Kesler, Christine
www.christinekesler.com

Kuhn, Margie
margiekuhn@sunflower.com

Walker, Carrie
www.carriewalker.ca

Wilson, David

Zlatkis, Geninne D.
www.geninne.com
geninne@gmail.com

RESOURCES

AUSTRALIA

Eckersley's Arts, Crafts, and Imagination
(store locations in New South Wales, Queensland, South Australia, and Victoria)
www.eckersleys.com.au

CANADA

Curry's Art Store
Ontario, Canada
www.Currys.com

Kama Pigments
Quebec, Canada
www.kamapigment.com

FRANCE

Graphigro
Paris, France
www.graphigro.com

ITALY

Vertecchi
Rome, Italy
www.vertecchi.com

NEW ZEALAND

Littlejohns Art & Graphic Supplies Ltd.
Wellington, New Zealand
Tel: 04 385 2099

UNITED KINGDOM

T N Lawrence & Son Ltd.
artbox@lawrence.co.uk
www.lawrence.co.uk

UNITED STATES

Art Suppllies Online
www.artsuppliesonline.com

Cheap Joe's Art Stuff
www.cheapjoes.com

Creative-Coldsnow Artist Materials and Framing
www.creativecoldsnow.com

Daniel Smith Artists' Materials
www.danielsmith.com

Dick Blick Art Materials
www.dickblick.com

The Earth Pigments Company
www.earthpigments.com

Jerry's Artarama
www.jerrysartarama.com

Kremer Pigments Inc
www.kremerpigments.com

Sinopia Pigments & Materials
www.sinopia.com

Utrecht, Cranbury Art Supplies
www.utrechtart.com

Williamsburg Artist Materials
www.williamsburgoils.com

Arches Watercolour and Drawing Papers
www.arches-papers.com

The Artist's Handbook: Equipment, Materials, Procedures, Techniques
Ray Campbell Smith,
(DK Publishing, 2009)

The Painter's Handbook
Mark David Gottsegen,
(Watson-Guptill, 2006)
thepaintershandbook.com
www.amien.org (forums)

Handprint.com
Bruce MacEvoy
www.handprint.com

PaintMaking.com
Tony Johansen
www.paintmaking.com

Reeves, since 1766
www.reeves-art.com

ABOUT THE
AUTHOR

Heather Smith Jones is a studio artist and instructor who earned her MFA from The University of Kansas in 2001 and her BFA from East Carolina University in 1996. Smith Jones is represented by galleries nationwide and has completed residencies at Arrowmont School of Arts and Crafts and Virginia Center for the Creative Arts. Her work is in the public collections of the Sprint Corporation and Emprise Financial Corporation and in many private collections. Smith Jones also collaborates with other artists in photography and multi-media projects. She lives in Lawrence, Kansas, with her husband.

www.heathersmithjones.com

(Right) Layers, (detail), watercolor on paper, 10" x 11" (25.4 x 27.9 cm).

Acknowledgments

To Mary Ann Hall, my editor who first contacted me with the idea and was amazing through the entire process; for answering endless questions and responding so graciously; for her continuous encouragement and reaffirmation—Thank you, Mary Ann.

To Rachel Saldaña, photographer and dear friend—for the talent she brought to this project, for working long photo-shoot weekends, "camping out," and for getting in my face and making us laugh.

To all the hands at Quarry that helped put the pieces of this book into one beautiful entirety including Betsy Gammons for her project management, David Martinell for his art direction, and to the designer, Nancy Bradham.

To the artists who contributed their wonderful work to the gallery—Thank you!

To the readers of my blog, for their loyalty and kindness.

To dear friends: Shari, for her letters full of poetry and inspiration that helped spur me on. To Alica, for her friendship and enthusiasm. To Alicia, for checking in and noticing. To Emily, for silently cheering in my corner.

To my co-teachers at The Lawrence Arts Center for their moral support.

To G. Webb, my first watercolor instructor.

To Paul Hartley (1943–2009) an amazing painter and professor, for teaching me about composition, ways of combining imagery, and for inspiring Project 12 in this book.

To Tanya Hartman, my graduate school professor who taught me about making paint by hand, to make every part of the painting interesting, and that without fullness of life, there is no art.

To my sister, for being who she is: lovely.

To my parents for searching and searching to find *the* photo, for giving me my first box of paints, years of endless encouragement, and so much more.

To my husband for continually believing in me, for always listening, and for helping me since the day we met.